Flying Lessons

Flying Lessons

ON THE WINGS OF

PARKINSON'S DISEASE

Joan Grady-Fitchett

A Tom Doherty Associates Book New York

FLYING LESSONS: ON THE WINGS OF PARKINSON'S DISEASE

Copyright © 1998 by Joan Grady-Fitchett

This book is printed on acid-free paper.

DESIGN BY BARBARA M. BACHMAN

A Forge Book
Published by Tom Doherty Associates, Inc.
175 Fifth Avenue
New York, NY 10010

Forge® is a registered trademark of Tom Doherty Associates, Inc.

Library of Congress Cataloging-in-Publication Data

Grady-Fitchett, Joan.
 Flying lessons : on the wings of Parkinson's disease / Joan Grady-Fitchett.
 p. cm.
 ISBN 0-312-86490-6
 1. Grady-Fitchett, Joan—Health. 2. Parkinsonism—Patients—North
 Carolina—Biography. I. Title.
 RC382.G69 1998
 362.1'96833'0092—dc21
 [b] 98-23437
 CIP

First Edition: November 1998

Printed in the United States of America

0 9 8 7 6 5 4 3 2 1

For E∂

Acknowledgments

The SANDHILLS
WRITER'S GROUP
for their encouragement
and friendship.

GLORIA T. DELAMAR
for her assistance.

HAROLD ROTH
who had the courage
to represent
an unknown author.

A little bird sits
Precariously
On a limb that
Swings
And yet he
Sings
Because he knows
That he has
Wings

A UTHOR U NKNOWN

Foreword

I *first met Joan Grady-Fitchett through her old medical* records that were placed on my desk. Those pieces of paper told me a lot about a unique individual. Joan did her homework and sought out the best; her previous neurologists were world class and I was going to have some tough acts to follow. She was gutsy and did not mind walking the edge of medical knowledge in her quest to maximize her life experiences. She had volunteered for experimental drug therapy in the clinical trials of deprenyl.

Joan did not play the victim; she did not hesitate to express her opinions about her therapy. The notes were loaded with discussions with her physicians concerning modifications on her medications. Joan was not just a businesswoman, but also had a very active lifestyle outside the workplace. References to real estate deals in her medical

notes, and the associated stress, alerted me to their effects on her response to treatment.

Joan had had Parkinson's disease for at least eleven years prior to her arrival at my office. She was already taking the major anti-Parkinsonian medications, and my chances of introducing a new "magic" drug would be limited. A good patient-doctor relationship is based on mutual trust and respect. Little did I know that a good sense of humor would be the third element of our medical foundation and friendship.

Walking into the examination room on her first visit, Joan confirmed my mental image of her when I saw a very elegant woman sitting in the appropriate chair. After the standard introductions, Joan reviewed her medical history and her current problems and concerns. Her next comment set the tone for our work together.

"Okay, that's the story. Now, I feel like Humpty Dumpty after the fall. How good are you with egg shells."

She gave me a great smile, and I had to laugh. We have been working together with her egg shell for the past six years.

Joan tells it like it is. She has no qualms describing the episodes of emotional strength and weakness, and I only hope that her efforts to share her experiences with others will be appreciated.

When I read *Flying Lessons* from the vantage point of a neurologist who has treated patients with Parkinson's disease for over eighteen years, several important elements of Joan's approach to life and her disease stand out. She illustrates what a significant role a patient's positive attitude plays in long-term functional survival with Parkinson's disease. Her physical work on her farm and her exercise program demonstrate their effectiveness in preserving an active lifestyle. Joan's experiences show that patients should participate in the medical decisions concerning their care and remain current with the available literature provided by Parkinson's disease organizations. As Joan emphasizes throughout her book, a good sense of humor can be essential for the patient, family, and physician.

I hope the readers enjoy the multiple facets of Joan as reflected in her book. It has been, and continues to be, an honor, a pleasure, and a learning experience to work with her.

PETER LARS JACOBSON, M.D.
Clinical Professor of Neurology,
University of North Carolina School of Medicine
Consultant, National Health Care Task Force

Introduction

W*riters are the architects of thought. We are the voices* of yesterday, today, and tomorrow. Poetry or prose, fiction or fact, words are our building blocks. How we cement these words together is called the creative process. The task is arduous and often unrewarding, but the one thing that most writers have in common is that in spite of themselves—writers write.

Writing an autobiography is a little bit like getting undressed in front of strangers, and I wouldn't have attempted it except for my need to share the human spirit that resides in all of us.

Churches make rules—whether to sprinkle or immerse, genuflect or kneel. Musicians write music—jazz and blues. And poets write poems—in rhyme and blank verse, but the human spirit is elusive. However, it resides in all of us, and

all you have to do to capture it is to listen to your heart beat.

Flying Lessons is about spirit and laughter. It is about my learning to fly on the wings of adversity and to smile at disaster in the hope that some of you, after reading this book, will hear God laughing and feel the wind on your wings.

> JOAN GRADY-FITCHETT
> Southern Pines, North Carolina
> 1998

Diagnosis

T his story *actually had its beginnings seventeen years* ago, but only now am I able to write about it.

I can still see the doctor's face. He seemed delighted at his discovery when he said, "You either have a brain tumor or Parkinson's disease. I don't think it's a brain tumor, but if it is, it's benign. I'll want you to have a CAT scan to rule it out." His face took on a supercilious grin. "It's such a good time to have Parkinson's disease as we have so many excellent drugs now that control it. We seldom get to see Parkinson's at such an early stage. You are a very bright introspective woman."

It was a short walk from the doctor's office to the parking garage, but it took forever. Somehow, I managed to get to my car before I started sobbing. "Pull yourself together, Joan. He has made an awful mistake and you will just have to get an opinion from a saner doctor."

This thought made me feel immediately better. Prepared to forget the ordeal, I drove back to the office. My concerned secretary asked what the doctor had said.

"We have choices today. I either have Parkinson's disease or a brain tumor. I hope it's a tumor." I smiled, trying to make it sound funny.

Several months went by before I scheduled the CAT scan. It was normal.

At that time, I was living in Miami, Florida, divorced for the third time, a reasonably successful real estate broker, living alone in a contemporary apartment with my Burmese cat, Goliath. For relaxation, I swam forty laps three times a week and played tennis on Mondays and Fridays. I was forty-seven years old, looked thirty-five, and considered myself a pretty woman.

My earliest symptoms were a slight stiffening of the muscles in my upper left arm and a slight loss of fine-tuning in my left hand. I am left-handed. My handwriting became visibly smaller and twirling spaghetti was almost impossible.

The symptoms began in late 1979 and got progressively worse. After several general check-ups with my gynecol-

ogist and my internist, who both pronounced me to be in excellent health, Dr. Caroline Hunter, my gynecologist, suggested that I see a neurologist.

After my tentative diagnosis, I sent for literature from the National Parkinson's Foundation. It explained that Parkinson's was a disease of the central nervous system with no known cure. The *substantia nigra*, a Latin expression meaning "black substance" because of its dark pigment, is a small area imbedded in the base of the brain. It produces a chemical substance called dopamine. The nerve cells of the *substantia nigra* send long thin fibers upward to connect with other nerve cells in the deep gray matter of the cerebral hemispheres, known as the *corpus striatum*. Dopamine made in the cells of the *substantia nigra* travels up these fibers to the *corpus striatum*, there to act as a chemical messenger transmitting signals to the nerve cells of the *striatum*. When the *substantia nigra* cells are injured or for some reason cannot produce or store dopamine, a deficiency develops in the *striatum*, which transmits impulses for the involuntary muscles to perform. If the deficiency is sufficiently severe, symptoms of Parkinsonism begin to appear.

Without medication, the patient deteriorates eventu-

ally to the point of being "frozen." The patient cannot move or talk or even blink his or her eyes. In about forty percent of patients, dementia occurs.

In addition, the literature discussed the apathy and depression that usually accompanies the disease.

I stood looking in the mirror admiring my still supple body and had difficulty imagining what might be in store for me in the near future.

My left hand continued to decline in dexterity and my main concern at that time was that I wouldn't be able to put on my makeup. I am happy to say that seventeen years later, when I wish to wear makeup, I can still apply it aptly.

Dr. Anderson, the neurologist who diagnosed my Parkinson's, was an abrupt, cold man, who I realize now had to hide behind those emotions because he was always giving bad news to people. This was the only way he could handle it.

On my first visit to him, he put me through a series of tests.

"Mrs. Grady, I am going to name five disassociated objects and in ten minutes I am going to ask you how many of them you can remember. A red ball, a black book, a green block, a yellow flower, a blue bell."

"There is no need to wait ten minutes," I said defensively, not knowing that this was going to be an inquisition. "I can't even remember them after ten seconds."

"Mrs. Grady, do you know who the very first vice president of the United States was?"

"I haven't the foggiest idea." I said getting more panicky by the minute.

"Do you know who the vice president is now?" He said in a very conciliatory manner.

"Bush," I stammered.

On my second visit to Dr. Anderson, I tried to be more prepared for his inquisition. For example, I knew that John Adams was the first vice president of the United States and the second president. Armed with these bits of information, I sat stiffly in a chair in front of his desk.

"Your CAT scan was normal, so it's just as I suspected, you do have Parkinson's," he said. "You know, Mrs. Grady, part of being alive is being ill, and the sooner you get used to that, the better off you'll be. I can put you on some medication called Symmetrel. It works in Parkinson's patients, but we don't know why. I think it will improve your tennis game."

I leaned across his desk, definitely in his space, about three inches from his nose, "What we are talking about

here, Dr. Anderson, is not my tennis game, but my whole fucking life."

Ray Mummery, my family doctor, and I discussed where I should go for a second opinion. He asked three neurologists and they all came up with the same name: Dr. Melvin Yahr, who was considered to be the foremost authority in the world on movement disorders.

It was February of 1982 and I was forty-eight.

Melvin Yahr was the head of the neurology department at Mt. Sinai Hospital in New York City. Ray set up an appointment. It is easy to understand that after my episodes with Dr. Anderson, I was apprehensive at seeing even the "best in the world."

I flew to New York several days early to visit friends and see a few shows, determined to make a holiday out of a somewhat tragic situation. I stayed at the St. Regis Hotel, treating myself to its understated luxury. I also scheduled in some real estate business, as I had French clients who had offices in New York.

Dr. Yahr's office was on the fourteenth floor of the Annenberg Pavilion in the Mt. Sinai complex, which takes up four city blocks at 98th Street and Fifth Avenue. I concluded that some people no doubt disappeared in this complex and were never seen again.

Dr. Yahr's offices were unpretentious. His reception room was full of people with neurological movement disorders. One man with very kind eyes seemed to jerk erratically every few seconds. This man must have cerebral palsy I thought to myself, surely it can't be Parkinson's disease. I exchanged pleasantries with the lady seated next to him on the couch to my right, who happened to be his wife.

"Oh no," she said emphatically. "He has Parkinson's, but the erratic movement comes from the medicine he's on. However we are very grateful for the medicine, because without it he can't walk."

Another elderly patient sat in a wheelchair, attended by her own private nurse. She sat with her arms bent like a dog sitting up begging for a bone. Her face was as expressionless as if she were wearing a mask. Saliva dribbled down her chin.

A woman in her early forties, bent sideways at the waist, her dress hitched up as if she had not been able to pull it down, spoke enthusiastically to the young gentleman seated beside her about the new Parkinson's aerobic class that Mt. Sinai was starting.

Others were in various stages of decline. I waited two and a half hours in this reception room before my name was finally called.

I was taken to a small cubicle where a Dr. Bergman took my medical history.

"You have been in the waiting room for a long time," he said. "It's pretty depressing out there."

"Do you deliberately schedule new patients for a long wait so that they have a forecast of what's to come?"

"No," he said, somewhat embarrassed by my query. "We have a lot of good drugs now to treat Parkinson's disease. Before Sinemet a Parkinson's patient had a life span of about ten years, but no one dies from Parkinson's any more."

"No, they die from the side effects of the medication," I said, trying to keep things humorous, but I don't think Dr. Bergman appreciated my humor.

"Dr. Yahr will be with you in a few minutes." He smiled, obviously relieved to be finished with me.

Dr. Yahr had a soft-spoken Boston accent and an easy manner. He wasn't tall, but his deep resonant voice seemed to make him almost Godlike. "Mrs. Grady, what can we do for you today?" he said while beckoning me to sit down.

"I have been diagnosed with Parkinson's disease and I'd like a second opinion." I sat down. "My whole life has

been prime time. I live alone and there is no one else to discuss this with except me."

Dr. Yahr's style was much different from the first neurologist. He asked me to tap my thumb and forefinger together in rapid succession, asked me to touch my nose with my finger, eyes closed, checked my reflexes, asked me to stand and tried to knock me off balance, and asked me to walk for him.

"Mrs. Grady, you have idiopathic Parkinson's disease. This means that it is of unknown origin. It should move very slowly and should only get worse with age. The disease starts in one side of your body and eventually progresses to both sides. You have an 'at rest' tremor in your left hand. It's the easiest tremor to deal with. The 'familial' tremor trembles all of the time. The 'action' tremor trembles when you are moving and is the most severe. The 'at rest' tremor only occurs when your arm or leg is still."

I felt my knees buckling under me. With a second opinion, I couldn't escape the fact that I really was ill and I bit my tongue so that the pain would keep me from crying. I could hear Dr. Yahr talking.

"If you are going to be in New York for several days I

would like to run a test on your tremor and take you off the Symmetrel." I agreed to stay.

My tremor was very slight in the three months I had been on Symmetrel. However, I had had no tremor before Dr. Anderson suggested I take the drug. Now, with the withdrawal of the drug, my tremor became more pronounced. I found myself keeping my left hand in constant motion to keep it from trembling and this was exhausting.

The results of the test that electronically monitored my muscle reactions confirmed that I had only an at rest tremor.

New York's hustle and bustle kept me busy for five days and then it was time to go home. Like Cinderella's coach, I turned into a pumpkin.

Goliath was very happy to see me, jumping in my lap, purring and kneading me. "Well kiddo, it's just you and me, and it's time we started considering our options. If all else fails, there is always suicide, but you're in good health and who would take care of you? Scratch suicide—no pun intended."

.....................................

Sorting Out My Life

I*t was time to sort out my life.*

Men had always been a necessary evil in my life, but when a perfectionist finds out she is flawed, her dreams suddenly become nightmares.

While I was sitting in attorney Martin Gould's office discussing a contract that had problems, Martin said, "There is nothing to be nervous about, we'll work it out."

The third time he said it, I realized my left hand was trembling. I smiled and in a well-modulated voice said, "I am not nervous. I have a neurological problem with my left hand."

George Cadman III, one of the owners of South Dade Realty, where I worked, had been in South America when I had been diagnosed. One morning he started staring at me across the room. "All right, what have you gotten into while I've been gone?"

A hush fell over the office, "George, I have Parkinson's disease," I said humorously.

"Well at least it's in your left hand, it could be worse," he said somewhat smugly.

"George, I'm left-handed."

Before Parkinson's, I had moved at the speed of light. Of course I found out very quickly that this was a No-No. I dropped things, spilled things, and broke things, until I came to grips with the "New Me." I had made up my mind to keep working as long as I could and it took some rescheduling of attitude to make it work. The secretary typed more of my contracts. I tried not to overbook myself.

All of my life it seemed as if my moneymaking endeavors, modeling and real estate, were either a feast or a famine. Clients didn't space themselves evenly in my life. There would be quiet days and then three clients would descend on me at one time, all requiring my absolute attention. Over the years, I became a master juggler.

Parkinson's didn't end my juggling career, it just made me a more selective juggler.

Bad news travels fast, and before Parkinson's I did more things right by accident than most people do on purpose. It's called style. When the news hit the workplace and my

friends' hot lines, some people were very concerned and some were probably elated. Oscar Wilde said, "You can tell the mark of a man by the magnificence of his enemies."

I had the reputation of being able to deal with difficult clients. I used to joke that when all of my clients were behaving, they were in their cages, and when they were being difficult, they were out of their cages.

One of my very wealthy and demanding clients called me at midnight and asked, "Where are my plastic plants?" I told him that we had thrown them away as per his instructions, which I had in writing. He asked about the globe light over the foyer. I told him that James, his butler, had probably taken it down to clean it.

"Why don't you ask him?"

"James is asleep, it's very late."

He clearly knew he had overplayed his hand and said abruptly, "I'll speak to you in the morning."

This same client called me one day and said, "Joan, do you know what slander is?"

"Yes, slander is when you say something about someone that is not true. I can assure you that anything I have ever said about you was true." He hung up.

Then there was an incident when one of my rental

houses was abandoned. My client's sister went by the house to see if the key she was bringing me would open the door and found twenty million dollars worth of cocaine and a lot of firearms in the house.

When the police came to interview me, I said, "Gentlemen, but for a quirk of fate, I would have been the one who found all of that cocaine. I would have been confronted with a very serious moral problem."

I was so outspoken that I know that some of my associates and ex-clients were secretly glad I was ill because they thought it would take me out of the marketplace, but much to their chagrin it didn't. Like Don Quixote, I had always been a windmill chaser, a champion of impossible causes, wounded animals, and humans.

Now I faced the biggest challenge of my life—me.

Before Parkinson's I thought I could fly. As Dr. Frederick Herzberg, a noted industrial psychologist, said, "An adult can have illusions, in fact, must have illusions, but they must be more mature. The childish illusion is, 'I can fly.' The adult illusion is, 'I can fly, but I have to develop a wing shape.'" In the months following my diagnosis, I knew I had to develop a new wing shape if I were to continue flying.

There was no special man in my life. For the past several years, I had been dating casually. After my third stab at marriage, which had ended very badly, I said to myself looking in the mirror, "Well, we know you can always get married again, but let's just see if you can stay single." I had been single since 1977.

My dating repertoire included a psychiatrist, an airline captain, an insurance executive, and a stockbroker, not necessarily listed in their order of importance. I relied more on my male friends than my female friends for sustenance during this transitional period of my life. The only one who survived the transition was the stockbroker, Milton. It was as if I were suspended in an emotional womb and blocked out all the sharp edges of my life, contented to be cushioned from reality. Milton was a gentle man who adored me and I accepted his adoration gratefully. We laughed a lot, played tennis, went to the ballet, spoke French, swam and dined—studiously avoiding the subject of my illness. It seemed as if someone had ordained Milton to help me recuperate emotionally. "Milton, wherever you are, thank you."

When tragedy strikes, a person is always in the middle of something, and because life has a continuous continu-

ity, good or bad, I had to decide how many of my future plans were realistic and which ones I had to abandon.

My trip to New York made me very aware that there was medicine and there was great medicine. If I wanted to stay ahead of this disease, I needed to continue seeing Dr. Yahr. I made an appointment to see him again in six months. After reading the Parkinson's literature and seeing people with advanced Parkinson's disease, I realized that what would work for me would be to surround myself with well people and read as much medically as I could. For example, Dr. Yahr could not be sure that I would not deteriorate very quickly, but there was no need to frighten me to death. As it turned out, his analysis was correct. I believe that the mind can do what you want it to do— look how many people die of fright after being diagnosed with an incurable disease.

Behin∂ the Ivy

M*ost people lead their lives as if they are going to live* forever, and I was no exception. After being diagnosed with Parkinson's, at first, I was in denial. Then I went back carefully over my life and trotted out memories. From my earliest recollection, I was never a strong child physically, but what I lacked in physical stamina, I made up for in tenacity and grit.

After I'd had pneumonia three times in the days before penicillin, the doctors told my father that if he wanted me to live past the age of four, I had to winter in a warmer climate than my native Atlantic City. My father chose Florida, Coral Gables to be exact.

Fifteen years later, when the counselor from Stephens College made a presentation at my high school, I went home and announced that the only college I wanted to go to was Stephens. This caused a great deal of anxiety in our

household, as Stephens was in Missouri. It gets cold in Missouri. However, I told my parents that the last time I'd had pneumonia I was six and penicillin had since been discovered. My parents reluctantly agreed.

Stephens College, whose main philosophy was, "It is easier to educate a woman like a man, but much more important to educate her as a woman," was in the sleepy little town of Columbia, Missouri. One of the "ten ideals" from the college handbook, *Behind the Ivy*, that I still carry with me is an "appreciation of the beautiful." Without this life has little meaning. The times in my life that I have quite forgotten this, disaster was never very far away.

While at Stephens, I was cushioned from disaster but too young to realize it. I was an English major, carrying twenty hours a semester. In three Stephens Playhouse productions I had the leading role, acting with such notables as George C. Scott, who was a staff actor, and Tammy Grimes, then a gifted student. Stephens Playhouse was considered one of the best in the country at that time.

I had started out with a one-hour acting course, but my advisor, who was on the Playhouse staff, had my high school records and knew that I had a theatrical background. He decided I would be just perfect for the role of

Cecily Cardew in *The Importance of Being Earnest* by Oscar Wilde. I was summoned out of one of my classes to read for the part. I was then *told* that I would be taking a three-hour acting course the next quarter. There were students who had come from all over the United States to have the opportunity I had handed to me. Life's like that. You can have anything in life you want—if you don't want it.

Later that same year, I played Diana in Jean Anouilh's *Ring Around the Moon* and kissed George C. Scott on stage every night for three weeks. I asked George how he felt I was playing the part.

"You are here to learn the craft of acting. You should be carrying the scene, but if you want to carry it, you'll have to take the stage from me."

And I did!

The fifties were a very naive time, and those of us who had the good fortune to be young adults in that era are now aware of just how innocent it was.

"A gentle woman never chews gum, never leaves the house without a handkerchief or her white gloves and never takes the Lord's name in vain." What are the four things a gentle woman never does? This question was on my world literature professor's exam. If you didn't know it,

you failed in spite of how vast your knowledge of world literature might be.

Then fate tempted me to leave these surroundings, where playing by the rules was a part of the everyday curriculum and exchanging ideas was conditional on your gender, to enter a world that would swallow me up if I tried to use these same rules.

Applause

Hands clap together
creating rhythmic vibrations
wind forced through air.

To the artist
basking and bowing
hubris is his rite
his ego bathed in cadence
as crackling sounds
penetrate the night

He soars like Icarus
too close to the sun
as sound ceases
he stands
wings scorched
alone.

First Marriage

I *married my brother's best friend, a relationship that* was doomed from its inception. My husband Bob was a starkly handsome man, eight years my senior, and I con- jured up his white horse as he rode seriously into my life. Actually, the horse never existed, which was a big part of the problem, because I have never been one to give up dreams easily.

One night he called me at Stephens and said, "I am going to be sent to Japan after I graduate from the Air Force flight school and I don't want to go alone."

"Is this a proposal?" I asked cautiously.

"I think so."

This was in early December. My friend, Audrey, who was a design student, designed my wedding dress. We had a formal wedding in March of 1954, complete with Pres-

byterian Church, Country Club reception, and live band—a story book romance.

Although we had known each other for four years, we only had about five formal dates.

On our two-week honeymoon in which we toured Florida, I learned to sleep uphill, with my arms grasping the mattress to keep from falling into Bob. My period came early, but it didn't stop the sex, which was totally one-sided, but it would have been out of the question to discuss this in the fifties. After all, I was lucky to have such a handsome man so interested in me.

In September of that same year, I flew to Japan on the "fly now and pay later," plan. The brooding, melancholy man who met me at the Tokyo Airport was a far cry from the earlier impression I had of my new husband. He had written wonderful letters.

In Bob's absence, I had acquired a toy poodle named Shelly, who I brought to Japan with me—Bob and Shelly hated each other at first sight. It was a constant battle to keep her from biting him and him from killing her.

We spent several strained days in Tokyo before embarking to Hokkaido, which is the northernmost island in Japan. We were two hundred and eighty miles from

Siberia. The people on Hokkaido used to say that they hoped summer fell on a weekend so we wouldn't miss it.

The first several months I spent a lot of time walking in the mountains clutching Shelly and crying, seven thousand miles away from home, unable to absorb the beauty of the majestic vistas before my eyes.

I had one period and then I was pregnant—and let me tell you all babies are not conceived in love. It's lust, mostly lust. My first born growing inside of me made me very nauseated. I threw up every morning for three months and lost nine pounds. For a while, I forgot about being so unhappy and was grateful just to be alive. I was angry that no one had prepared me for what life was really all about. I prayed that our relationship would get better.

Cheryl was a month late making her debut into this world, but when she finally arrived, this little person in my life, became my life. She was just perfect and the prettiest child I had ever seen. Finally there was something meaningful for me.

It would take seven years and three children, with me only reaching orgasm in my dreams, to realize that there was much more to life.

When Bob got out of the Air Force in 1956, he went

to work for Eastern Airlines, and I was told, "These are not my condoms, these are large. I was just carrying them for the captain."

There was never enough sugar in the sugar bowl or salt in the saltshaker. He told me that my over-easy eggs were tough and said, "Your mother's stupid," grinning at the children.

One can only subject oneself to so much bullshit and it becomes impossible to shovel fast enough to not be covered in it, so I bailed out and was cast very unceremoniously on the market with three preschool-aged children.

My father was a sophisticated "Archie Bunker" who loved my marriage, my airline pilot husband, and his three grandchildren. When I interrupted this image, he made my life difficult by trying to preserve his happy little world, no matter how painful it was for me. Trying to reason with my father once he got his mind made up was an impossible mission. We had been extremely close when I was growing up. I missed his support during this difficult period. It was crystal clear to me that my father liked *winners* and this was the first time in my life that I had disappointed him.

My relationship to my father had been unique. Even

though I had a brother who was four years my senior, I was my father's boy. My mother and brother were afraid of him. He was never physically abusive, just very domineering. I came into the world a rebel and being so ill during the first years of my life made me even stronger. If blood-letting had been in style, the doctors would have tried it on me.

The first time I had pneumonia, my left lung filled with fluid, a condition they called empyema. They had to surgically remove a part of one of my back left ribs and insert a tube into my lung, and my back drained for six weeks. I was two years old.

My father's strength kept me alive. There were four doctors treating me and none of them knew what was wrong. My father consulted with them and called in the fifth specialist. He diagnosed the empyema and they operated immediately as the fluid was about to drown my heart. On the way to the operating room I remember asking my father if I could sit up, and he lifted me to a sitting position bracing my back with his arm as they wheeled me down the hospital corridor and into the operating room. Doctors were not tuned into children in 1936, and they explained nothing. I remember large adults in masks holding me down and putting the anesthetic mask over

my face. I had nightmares about it for years. I thought they were trying to kill me.

However, I did live and had two more bouts with pneumonia before I was four.

My brother was a placid child who followed directions and always smiled on cue. He and I were opposites from the very beginning. He was a very cautious person and very much like my mother. They were afraid of confrontations and most of the time I stood up to my father for both of them. Perhaps once you have looked death in the face at such an early age and won, very little frightens you about life.

Picking Up the Pieces

A*fter my separation from Bob, there was a six-week* period in which no bills were paid. I barely had enough money for groceries. Stephens College seemed a million light years away, and I had to make some decisions about my future. However, now I had a whole entourage—my three children. I was a package deal.

Before my marriage, in my college years, I had a photo-graphic memory; now it was impossible for me to remem-ber my name from the front of the house to the back of it.

I had modeled as a teenager, but I was twenty-seven now. It took several weeks to muster up the courage to call MJ at the modeling agency in downtown Miami. She remembered me from my teen years. She was cordial and encouraging on the phone, and I made an appointment to see her. Feeling painfully thin and inadequate, I sat across from her, twisting the handles of my purse.

"You look good," she said smiling. "I'll want you to have a makeup analysis. It's nice to have you back."

There was an awkward silence. "We'll have lunch some day soon," she said.

The road back to beauty was embarrassing and at times, humiliating. My first assignment was for Dave M., whose wife was his stylist. We shot some J.C. Penny catalog layouts. I learned a lot from Dave, but his wife was a very difficult and demanding person. I made the rounds of the other photographers, but my first composite (brochure left with the client) wasn't very exciting. Gradually I became more relaxed with the camera and my pictures got better.

In my modeling travels, I met a man named Bernie, who had a studio where local and out-of-town producers could process their video and audio tapes. He took an interest in me and became a mentor of sorts. He taught me to have a love affair with the camera. We would often work in his studio at night, and even though he was an absolute gentleman, he used to tell me, "When you are on an interview, make them think you might, but don't."

As part of my post-divorce therapy I took piano and water skiing lessons. I was klutzy at both, but the water skiing went better than the piano. The piano is an in-

strument, it seems, as are so many others, that favors right-handed people. The right hand carries the melody and the left hand plays the chords. I am left-handed, hence my chords overshadowed the melody. If I had persisted long enough, I might have eventually been good enough to play Chopin—he was left-handed. He wrote melodies for the left hand and evened the score between the rights and lefts.

My water skiing progressed a little faster than the piano. I learned to slalom—ski on one ski. After learning to do a few tricks, I began to look somewhat professional, even using my water skiing skills when I modeled. As a matter of fact, the more tricks you knew how to perform, such as diving, horseback riding, tennis, swimming, and so on, the wider your scope of modeling work for television commercials.

Meanwhile, on the homefront, my firstborn entered first grade. I was so proud of her. After school had been in session about two weeks, we had teacher home visitation. Cheryl's teacher was a mousy little creature who almost never smiled and never looked you in the eye.

When she arrived for our visit, she didn't look at me. She kept saying things like, "You're divorced aren't you?" "Do you think this has had an effect on Cheryl?" "Does

she follow directions at home?" "Did she attend kindergarten?" "Did she have any of the reading readiness program?"

I concentrated on trying to find her eyes, until I realized she was saying negative things about Cheryl. I kept trying to interrupt her to answer her questions, but it was obvious to me she had already concluded her own answers.

"Stop right there," I said gathering momentum. "You have said quite enough. Before you go any further, I think you should know that she is the pick of my litter."

When Cheryl was six and my son Bobby was four, I tried to prepare him for kindergarten that next year, talking about all of the new little friends he would meet. He kept saying, "Why can't I just stay home with you?"

"Because I'm your mother. I want you to go out into the world and conquer it for me. I want you to learn to read and write about all of the magical things there are, to see and do."

He looked at me for a few seconds and sighed. "Well I'll go, but I'm not coloring inside the lines."

So much for my mothering skills. All that I can say is that I never lied to them. I presented life as it was, the good and the bad. I tried not to judge other people and to make life a fun adventure.

My youngest, Claudia, was the least affected by the divorce because she was so young. She was eighteen months old when her father was told to leave the house. Bob was always saying, "Isn't it time for this child's nap."

"She just got up," I would say defensively.

Second Marriage

When *the phone rang one night, a strange male voice* on the other end said, "Hello, I'm Henry. I'm a friend of Joan and Jack C's. They gave me your name. I thought that maybe you would like to have dinner one night this week?"

"I am sorry but I've had a few brief encounters with the opposite sex and I don't think that at this time I'm emotionally equipped to date."

He started to laugh. "Well you can't get into too much trouble on the phone. Would you like to tell me about it?"

I was somewhat taken aback by his sense of humor and we started talking. We spoke on the phone four or five times for at least one-hour intervals, and by this time I was curious about meeting him. He had listened to my demands about no sexual manipulations, that it wasn't even open for debate, and he agreed.

He was the opposite of Bob. Five foot, ten inches tall and weighing about one hundred and thirty-eight pounds, he had a pleasant face and an outstanding voice. Henry had his BS in physics, and during the years that I dated and subsequently married him I didn't need an encyclopedia. Henry taught me to think. He was brilliant and honorable—a rare combination. I read extensively—Bertrand Russell, John Maynard Keynes, Aldous Huxley, Ayn Rand and many other thought-provoking authors. His friends were all intellectuals. He used to say, "I hold no belief that twenty minutes of intellectual conversation cannot change."

We dated for at least two and a half years, but he proposed to me after we had been seeing each other about four months.

Henry was true to his word—he didn't push me into any sexual encounters until I wanted him as much as he wanted me. He opened up a whole new world for me. This is what life was supposed to be like. Most things in my life disappointed me—they were not as good as I had imagined, but sex with Henry was better than anything I had ever imagined.

My modeling career was a mirror image of my happi-

ness, and suddenly I was in demand. But like all things in my life, as I was approaching the top of one mountain I was looking for another mountain to climb.

Sex was always rearing its ugly head on modeling interviews, and I lost work because of it, but with my luck I would have slept with the director and still not gotten the job.

Two incidents stand out in my mind. I had gone on an interview with about three hundred other hopefuls. It was a cigarette commercial, and it required the main woman to be a capable horseback rider, which I was and I told them so. I made it to the final cut—there were just five of us and they were interviewing privately now. The film was to be shot on the west coast of Florida.

"Do you mind if I ask you a strictly hypothetical question," the director said quietly. "What would you say if I told you that this job was contingent upon your sleeping with me?"

"Strictly hypothetically, I would tell you to go right straight to hell, do not pass go and do not collect your two hundred dollars."

I didn't get the job—a girl who couldn't ride did and the gossip in the trade was that they had to scrap the

whole film. Several months later I saw Sam, the director, at a local restaurant.

I smiled and whispered in his ear, "I understand that turned out to be a very expensive piece of ass." He laughed.

The other incident was with a photographer who was known to be a womanizer. I worked with him on Rubber Maid layouts for two days, then Claudia, Cheryl, and I worked on a Quaker Oats campaign for several days. At the end of the shoot, he told me that he was going to the Bahamas for five days and would I be interested.

"That depends on the arrangement," I said.

"I really like working with you, but if you were me and you could take someone with you that would amuse you after hours and someone who wouldn't, who would you take?"

"That is not my judgment to make, but it won't be me."

Several months later, I saw a model friend of mine and she stopped me. "A couple of months ago, I got a job in the Bahamas for five days because I looked like you. I'm glad you were busy, because he really liked you."

The next two years were busy, productive years for me. My relationship with Henry grew deeper, the children

grew bigger, and my modeling career flourished. On December 23, 1963, Henry, a bachelor of thirty-four years, married me, a woman with three children, in a private church service. Friends had a small reception for us afterwards.

Our Big House

My little house in the Westchester section of Miami was too small for any of us to have any privacy, so Henry and I went house hunting. I really liked Marion, our realtor. I liked her style, businesslike attitude, and taste in houses. We wanted to find a house that was in need of some TLC and get a good price since we had a beer pocketbook and champagne tastes. We found the perfect house. Abandoned by the owner and foreclosed on by the bank, it was in the very best school area in an excellent neighborhood. Excluding the two-car garage, it was 4,000 square feet under the roof. There were four bedrooms, two and one-half baths, a family room, a den, and a formal dining room, all on one acre.

The children were in Connecticut visiting their father when Henry and I moved in. When the movers left, the house was still empty. We had taken furniture from a

1,300-square-foot house and moved into a lot of space. This was in July of 1964.

The children didn't seem to miss the old neighborhood and the swimming pool they had left behind. Henry promised that we could build a pool at the new house. It was a promise he kept.

Modeling became more demanding and my schedule more erratic. I would get a call from the booking agent at ten o'clock the night before to be on a plane leaving at ten the next morning.

The children had reached an age where they had schedules of their own—ballet, little league, piano lessons, Brownies, riding lessons, and Cub Scouts. Rescheduling on such short notice became more difficult.

Henry suggested that I give up my modeling career and stay home, but I had a big house to furnish and a husband with a new business. I kept up the pace of being a super mom, super model, and super wife, while I painted and decorated the entire inside of the house myself. Gradually it began to erode my health and I seemed to get one minor infection after the other.

Henry designed and built the top "D" sports racing car in the country. It took him three years of working five or six nights a week at a friend's garage. He was always home

for dinner and was a wonderful father to my three children, but our schedules were so busy that I felt that I had to make an appointment to see my own husband. The time he had devoted to me before we were married now went to his race car, and although he loved me very much, he seemed to be content to neglect me. It broke my heart.

I would find myself away on assignment with very attractive people with everyone giving me maximum attention and then coming home to be the maid. One night as I stood outside my hotel room, a handsome young man who I had been working with all day asked if he could come in. I found myself making excuses that the room was a mess when I should have just said "no." It frightened me that I would even entertain such an idea. I knew that if my marriage to Henry was going to last I had to quit modeling. So I did.

After I was home for several months, money started getting tight and I started to get bored. The money problem was compounded by the fact that my father and my uncle got together one night and decided to buy Cheryl a pony and pay the board bill for a year. If I had had any sense at all at that moment I would have bought Cheryl a tennis racket. When she got tired of tennis, she could

have just put the racket in her closet. The racket wouldn't have to eat and be boarded.

Cheryl was thrilled, and I really didn't have much of an argument since I had had horses when I was growing up. Henry, however, was not thrilled and kept saying, "Nothing good can come from this."

Real Estate

A*fter several more months of boredom and too much* month for the end of our money, I began to think seriously about real estate as a profession. I called our realtor, Marion, and quizzed her about it. She suggested that I contact Arthur W.

Arthur W. was a portly man with a small mustache and a large ego. He offered the only real estate "cram course" in Miami in the mid-sixties.

There was a sign in a run-down storefront building on S. W. Eighth Street, "Arthur W.—Real Estate School." I signed up for the course.

Everyone took their seats. There were about forty of us. Arthur greeted us by saying, "Some of you will pass and some of you will fail, the choice is in your hands. I will not permit talking or the passing of notes in my class. The punishment for these offenses will be dismissal; then you

will have to try and pass on your own," he said with obvious pleasure at his autonomy.

He had the knowledge that we needed, and so for the next two weeks, all of us kept our mouths shut and our eyes open. On my final test at Arthur's, I made an 89, so I thought I was prepared to take the state exam.

Our next door neighbor, I.B., one of the owners of SD Realty, recruited me for his office. He was a widower and a good neighbor. I accepted. The next month, I cringed every time the mailman came. Finally, four weeks to the day, the official letter came. My hands shook as I tore it open and read "You passed."

Once I got settled in at SD Realty, I took to it like a duck takes to water. It was so much easier selling a product than selling myself and not nearly as competitive in the early days. Realtors by and large are friendly, gregarious extroverts who like to move into your space if you let them. In the mid-sixties, real estate was in its infancy in South Florida, and I was one of the lucky people to be involved in it.

When I left modeling, my face was on billboards all over the east coast. I had made it to the top and then walked away. A pattern seemed to be forming in my life.

In real estate, I could set my own hours and my own

schedule except for floor time (time delegated to be spent in the office answering phones). I no longer had to concentrate on being perfectly groomed. I could spend some days with little or no makeup.

Instead of taking it slowly, I plunged right in, and it didn't take long before my schedule was overwhelming, but I was making money without having to depend on the whim of some director. Perhaps, looking back, it was only an illusion, but I felt more in control.

Meanwhile, Cheryl and Claudia were getting deeper and deeper into the world of horses. We sold Cheryl's pony and bought her a horse. Then we bought Claudia a pony. We entered the world of horse showing. What really started to evolve there was that I was selling real estate to support my animals.

Horses are extremely time consuming and real estate is extremely time consuming. You put it all together and you have a nervous breakdown special. However, I was made of pretty stern stuff and I just kept on going.

Henry, of course, who didn't even like horses, was irate. He came to me one day without my having to make an appointment and suggested that if he were to give up his racing car activities, would I consider giving up the horses, but it was too late. Cheryl was a superlative rider

and Claudia was into her own excellence. I couldn't take this away from them because it was so rare in the sixties to have such a rapport with your children.

It would seem that from this day forward my relationship with Henry started going downhill. It was a gradual deterioration, but once a relationship starts to sink, it's difficult to keep it afloat.

Henry resented the fact that the money I was making went for "pink elephants." This was my way of saying that I was working so that everyone could have their luxuries and life would be more fun, but Henry felt that my money should be programmed. We violently disagreed about this issue.

In early December of 1971, I was getting my usual Christmas lecture, that under the threat of death, I was not to buy Christmas presents for the entire world again. The conversation deteriorated into Henry raising his voice, "I'm tired of everyone telling me how *neat* my wife is. I don't want to be Mr. Joan Grady."

"I think we need to go for counseling," I said quietly, fighting back the tears.

...................................

Counɟeling

Dr. L. saw Henry and me *separately and then he saw*
us together. "I can't possibly counsel you together; I will
need to work with you," he said looking directly at me. I
was stunned.

Driving to the north end of town for an important
business meeting, I tried to compose myself, but the
tears kept coming. "You have been crazy all of your life,
Joan, and no one ever bothered to tell you except this
doctor."

Later that day, I called Dr. L. and made my first ap-
pointment.

His office was full of comfortable leather chairs and
couches. I picked one and sat down as he ushered me in.
He sat behind his desk.

"I think that I had better disclose to you right up front,

that I was apprehensive about having you as a patient because after I first met you at a cocktail party, I fantasized about you for weeks."

"Well now that we have discussed your problem, shall we talk about mine?"

I was in analysis for three months. Dr. L. helped me sort out all of the guilt that I had been carrying around with me for years and it changed my life. I knew that my marriage to Henry was over, but he was such a good person that I wanted to wait and live with the NEW ME for a while.

In that next year we were to finish decorating the house as I had always wanted it, only to sell it and take the profit. We built a large duplex and moved.

Henry and I were divorced in the fall of 1973. After the divorce we went out to dinner that night and remained good friends. It had been ten years, with more pleasure than pain.

Shortly after Henry and I got our divorce, interest rates skyrocketed to twenty-two percent and real estate ground to a halt. I had two children in private school and one in college. I was more than a little anxious about this situation.

I was working long hours and not making any money. I could always get my father to help, but then it meant losing my independence, something that I had fought very hard to maintain my whole life.

Marriage Number Three

I had studiously avoided reading self-help books, so there was one phrase in *I'm OK—You're OK* that I missed, and it was the biggest omission of my life: "Sooner or later, the rescuer becomes the victim."

Jim was introduced to me by a mutual friend, who told me Jim was forty when in fact he was thirty-seven, and told Jim I was thirty-eight when in fact I was forty.

I had been working very hard, so when this charming, boyishly handsome man with blue eyes and sandy brown straight hair that fell casually around his face started to wine and dine me and present me with candy and flowers, I was very vulnerable and flattered. It took about three months and I was very involved with him.

He told me that he was having financial problems and convinced me that if we were married, the marriage

would protect his assets since Florida is a very lenient state for debtors.

I will say very little about the marriage except that I tried to rescue him.

When I finally asked him to leave he disappeared, leaving me to cope with all of his creditors, who were soon at my doorstep looking for him. I look back on this time of my life as a temporary madness. In the brief year and a half that we were married, both of my parents died. The night my father died, my mother had a stroke and died twelve days later.

This was the low point of my life. When my father died, I was in shock and married to this man, who I felt was extremely unstable.

My father was forty-one when I was born and I was forty-one when he died. I had never really considered life without him, and the fact that I was so unhappily married at the time almost took me under. You are really never an adult until your parents die. The year was 1975.

My father and I argued about two things in the last two years of his life—his doctor and his attorney. His doctor couldn't save him and I was left to cope with his attorney.

In the middle of all this, the final year of my mother's

and father's lives, I was president of the Florida Hunter and Jumper Association. Many horse people are notoriously difficult—rich, spoiled, and devious. Trainers were drugging horses and then putting small children on them and asking these drugged animals to jump fences. I did a lot to clean up this situation while I was president, but for my efforts, I had my tires slashed, a horse poisoned, and my life threatened. My life has never been dull.

After my father's estate was settled, I had a great deal more financial security and was able to cope with the slow real estate market.

The Farm

Toward the end of my marriage to Number Three, I had flown to North Carolina in the middle of February and looked at a piece of property in Marshall, thirty-five miles northwest of Asheville.

On the last ten miles of our journey, a narrow, winding road unfolded and climbed slowly to 2,800 feet. We ran out of paved road and went into a wide valley surrounded by mountains. Snow flurries filled the air and fell on the already frozen ground as the broker drove his jeep over a rickety bridge.

"Loy Buckner owns a sixty-acre farm adjacent to the property you will be looking at today," the broker informed me.

I stared at this country man as he introduced himself. Loy could have been a leprechaun in disguise as he wasn't much over five feet tall. His craggy face was accentuated

by a prominent jaw and Popeye nose. He was dressed in a torn, faded hunting jacket and old army boots. A frayed cap sat slightly askew on his balding head.

I watched his dark eyes dance mischievously as he assessed me, in my designer jeans and jacket—obviously a city lady.

After a long pause, he grinned, "Howdy, you planning on moving here?"

I smiled back, amused, "Maybe."

Loy volunteered to take the broker and me up the mountain road that formed the boundary of the forty-acre farm that was for sale.

I remember standing on the back of Loy's old Ford tractor on the narrow mountain road, my gloved fingers frozen to the fender. At times the tractor skittered near the edge and we had a clear view of the fifty-foot drop below us. Untouched snow collected on rusting barbed-wire fences, the wind whipped my hair and stung my face. It felt good to be alive.

After about an hour of curious starts and stops, Loy's tractor crunched to a halt beside his house.

"Can you come in and set for a spell," he asked.

"That would be nice." I smiled looking to see if the broker had time. He nodded his head.

"Howdy, I'm pleased to meet you," said Loy's wife, Evelyn. She was a sturdy woman with home-permed black hair and a pleasant face. She was Loy's opposite, shy and reserved.

Seated at their round table in the bright yellow kitchen warmed by a wood stove and the aroma of freshly perked coffee, I felt at home. It would be the first of many conversations in that comfortable kitchen, often laden with food. Loy was a farmer and a carpenter. I never considered anyone else for the renovation of my farm.

I spent the next several months researching the area. In the early spring, I made an offer and the farm became mine.

In July, my marriage came unraveled and Number Three sued me for alimony. We were assigned the only judge in Dade County who had ever awarded a man alimony. Needless to say, we settled out of court, and I had his name erased from all of my real estate holdings and took back the name of Grady. Henry and I had different philosophies, but we had remained friends.

In May of 1978, I went to North Carolina to see if I still had the same feelings about the farm or if I should sell it. In contrast to the starkness of winter, the farm was now an explosion of growth. I saw fields of green inundated

with thousands of ox-eye daisies standing at attention. Wild pink rambler roses wandered possessively over stacked rock fences, and purple iris, once carefully tended, presented themselves in large disorderly clumps.

I stopped the car and began running through the fields, my face moist with tears. I knew the farm was a "keeper."

That summer I spent as much time in North Carolina as work would allow. I followed Loy, with his quick loping gait, over as much of the farm as we could see in a single outing. As we investigated all of the old barns and out-buildings, Loy provided a continuous monologue.

"This used to be the Doyle-Worley farm. Up in that holler is where Dr. Bob used to live. He was an herb doctor and cured people without store medicine. He birthed my three young'uns. Be careful! This time of year snakes comes out to sun themselves." He stooped over and picked up a pointed rock. "This here's an Indian arrowhead. You're a pretty young'un. How come you ain't married?"

"Just lucky, I guess."

On subsequent outings we would hunt for ginseng, a rare herb that grows wild in the mountains, or look for hummingbird nests. Occasionally we searched for lost cattle, as Loy had a very relaxed attitude about his fences.

Evelyn, Loy's wife, sensed the intensity of our friendship and was content to let us go on our excursions and feed us when we returned.

In July of '79, I retained an architect. After inspecting all of the building possibilities, it was decided that the old tenant farm house would be the best choice.

Later that day, Loy said, "I hope you and me are still friends when this house is done."

"But you've built lots of houses, Loy. What could go wrong?"

"I never worked for anybody who had an arch-ee-tect before," he frowned.

The work on the house began in 1980. It was extensive and expensive. We had just a shell to work with. We built a stone foundation, a stone fireplace, put in a new kitchen, windows, electrical wiring, French doors, all new plumbing—the house had no plumbing—and wooden decking on three sides. We put new wooden siding on the house, a new tin roof, and a well and pump.

In February of 1981 Loy was diagnosed with lung cancer. He died in April of 1982, two months after I was diagnosed with Parkinson's. Loy's death and my Parkinson's disease in one year would have been enough to put many

people under, but it made me more determined than ever not to let fate push me around.

Loy's first cousin, Leonard, and Frank Caracci, a semi-retired engineer, finished the farmhouse in the summer of 1982, but Loy's quaint touches were everywhere. The French doors were in backwards, and the electrical panel was in the living room, eventually to be covered by a painting. Each step of the staircase was a different shade of pine. There was a hole the size of a silver dollar in my bedroom wall and nothing was plumb. They were his legacy to me. They were "Loyisms."

I guess subconsciously I knew I would move to North Carolina, but it was not something I verbalized until February of 1983, when my Aunt Irene died and her estate was settled. I would now have the necessary funds to move.

Moving

At *the time I was diagnosed, my three children, all from* my first marriage, were scattered. Cheryl, twenty-six, the oldest, had returned to the University of South Florida in Tampa to finish her senior year. Bobby, twenty-four, was in the Navy. He and his wife Pak, and my grandson George, four, were stationed in Virginia Beach. Claudia, twenty-two, my youngest, was married to an Englishman and living near London.

I had convinced my children that I was invincible, so the news that I had Parkinson's disease was taken like all of my other crises—Mom will handle it. I really didn't want them to be afraid of me.

When Cheryl was in school, she would come home for weekends and then began to notice little things before the diagnosis. "Look at you," she said, one evening when we were having spaghetti. "You're having trouble twirling

your fork. Don't tell me the doctors say it's nothing. There is something very wrong."

Cheryl graduated in December of 1982 and returned home to live with me and my cat Goliath and to work for the American Cancer Society. When I made the decision to move to North Carolina, Cheryl decided to move with me.

The next five months were busy but full of hope and excitement. We got estimates from movers, decided what furnishings we were taking, and had a garage sale. I decided to keep my commercial accounts and phase out my residential clients.

I referred them out to Billie Turner, an associate in my office, and made arrangements to stay with Billie and her husband when it was necessary to return to Miami on business. I had a phone and an answering machine installed in one of their guest bedrooms. I put my phone on call forwarding to a live answering service in Asheville. It was an excellent service, they answered the phone SD Realty, and later on, when I formed my own company, Jo-Gra, Inc., I would pick up my messages several times a day, and if it was a really important client, the answering service would call me at home.

Work was very frustrating at times until I dealt with the

problems. I seemed to dial a lot of wrong numbers, but I just attributed that to being over forty, not to the Parkinson's. We don't appreciate what a marvelous machine the body is until it starts malfunctioning—particularly the brain. Subtle things like folding a letter and putting it in an envelope, talking on the phone and writing down a message, or carrying a real estate multiple-listing book, your purse, and sunglasses without dropping anything. It was as if there was an emotional short circuit and I had to repair the wiring. Many Parkinson's patients don't try to repair their short circuits—they give up. I know there were many times I was near tears when my circuits got overloaded, and apathy is always waiting in the wings.

Well-meaning friends and relatives give sympathy and that compounds the error.

I was aware, however, that sympathy was between "shit" and "syphillis" in the dictionary. Living alone helped a great deal in the beginning because I had to deal with my motor problems on my own. By the time that Cheryl came to live with me, I had learned what would work and what wouldn't work, and she knew better than to interfere on those occasions when something I was doing was not working.

One incident that we both still laugh about concerned

my very long nails, which I manicured and polished my-
self. One morning my maid, Mary, was cleaning and I was
doing my nails and the phone was ringing off the hook.
Mary kept answering it and I kept picking up the phone
and smudging my polish. Finally I said to Mary, "Put the
answering machine on or my nails will never get pol-
ished."

The phone rang a few minutes later and it was Cheryl
calling from work. "Mary, is Mother there?"

Mary sighed and under her breath she said, "I hope
them nails is dry!"

Cheryl was more anxious about the move than I was.
"Mother, don't you think that you'll be bored in North
Carolina?"

"I might as well be bored in North Carolina because I
am bored in Miami."

The days flew by and on July 22, 1983, the packers
came and the next day the movers came. Cheryl, Goliath
and I left Miami at five P.M. and embarked on our new ad-
venture with the same spirit that Columbus must have
had when he started out in search of a new world. We
drove as far as Orlando for an overnight, arriving at our
destination at about five the next evening. We collected
a few groceries before heading up the mountain road. The

house, sparsely furnished, had beds, linens, towels, a kitchen table, and eight director's chairs.

We unloaded the car and sat out on the deck taking in the view and inhaling the crisp, clean mountain air. Surrounded by mountains, I let my voice sing out "Hyperbole" and heard—BOLEE-LEE lee lee. We named the farm Hyperbole—an exaggeration of life.

Settling In

 O *ur first baby chicks came UPS, and we kept them in* a box in the living room. It seemed like the only sensible thing to do, as our chicken coop was too close to the woods, and weasels and foxes considered chicks a gourmet item in their diet. Our second acquisition was a sable border collie, purchased in August. We named her Julie, because she was born on the fourth of July.

Two things of note here pertaining to my Parkinson's disease were that Cheryl and Leonard (Loy's first cousin) decided to be my caretakers, and I decided to take some of their help, but in many instances I knew I had to do it myself. The delicate balance of accepting their help, while still doing my own thing, became an art form.

We were exceptionally lucky in the fact that although the country people who were our neighbors didn't think

we had a snowball's chance in hell of surviving the first winter in the mountains, they liked us. They were fascinated by our tenacity.

When the chicks got big enough, we moved them to the corn crib just below the house so that the weasels and foxes would have farther to travel for a free dinner.

Another shock to me was that I thought because I had played tennis several times a week and swam forty laps in the pool a couple times a week I was fit, but let me tell you the mountains of North Carolina will bring you to your knees until you get shipshape. There was not a flat place on the farm. Some of the hills gently rose and fell, but they were not flat.

I could tell by the expression on Cheryl's face as she was talking on the phone that she was excited about something. It seems that the lady that was boarding Eli, Cheryl's chestnut thoroughbred, who had carried her to her championship, could no longer keep him.

We had an arrangement with this woman in Tennessee who had agreed to feed and board him in exchange for the right to ride him.

"Mother, can we go and get him and bring him here, now?"

"He may be ill. You haven't seen him for six years."

"I know mother, but I will know that he died here with us."

So Eli was brought to the Hyperbole in a borrowed truck and trailer in November. He had not been well cared for and was skinny and wormy.

The vet who came out told us that other than the fact that he was wormy and thin and needed the attention of a good farrier, Eli was healthy.

The barn that we were renovating was three hundred feet from the house, but we hadn't planned on having a horse so soon. The barn wouldn't be ready for winter, so the corn crib shed below the house was made ready hastily for our latest arrival.

We purchased a lightweight rotary lawnmower, which I could use, and a gas-driven weed whacker about which Cheryl announced, "This is heavy, difficult and dangerous and should never be used by someone left handed; particularly someone with Parkinson's." After that gauntlet was thrown down, I knew learning to master the weed whacker was high on my list of priorities.

The next day I said to Cheryl, "Show me how to start this thing."

Cheryl gave me one of her troubled looks and proceeded to cautiously explain how to start and use the

weed whacker. There was a harness that snapped to the whacker and went around your shoulders. One handle controlled the gas flow and the other hand guided the machine. As I followed Cheryl's directions, suddenly the machine came alive. It vibrated my entire body as if I were in the worst state possible with Parkinson's. I felt as if I would become airborne at any minute. Obviously this was a machine to be reckoned with. I controlled this hostile projectile long enough to prove my point to Cheryl, but it would be at least a year before I tackled it again.

Between trips to Miami on business, acquiring animals for the farm, building fencing, and my yearly excursion to New York to see Dr. Yahr, I stayed busy and gradually gained strength.

In the early days of the disease, I was very clever at manipulating my left hand so that it wouldn't tremor. Everyone that I was relatively close to knew I had Parkinson's, both in Miami and North Carolina, but I didn't present myself as an ill person. I have found that people will accept you as you are if you accept yourself. Living with the loss of power that comes with the disease was distressing at first. Little things like unscrewing bottle caps or writing with carbon paper on which you had to bear

down to make the copies underneath legible was extremely difficult for me.

If my left hand was on the wheel while driving my car, I couldn't take my eyes off the road because I had no sensitivity in my left hand to feel the road.

Going to the grocery store, I had to plan my movements in advance such as taking out my wallet or checkbook and mentally rehearsing my movements. Carrying bags of groceries became exhausting. It was almost as if I had to reprogram myself, and I did most of the time. On a bad day, folding sheets and towels became nightmarish tasks, but I lived for my good days and tended to deny the bad days.

I didn't dwell on my illness. It was something I had to cope with, and I did.

Deprenyl Program

In March of 1984 I had my yearly checkup with Dr. Yahr. He told me that they were testing a new drug called deprenyl that was supposed to arrest the disease and asked me if I would be interested in the program. It would mean coming to New York every four months to be monitored. The "arrest the disease" stood out in my mind. Of course I said, "Yes."

At this meeting I asked Dr. Yahr if there was something he could recommend to help me control my left-hand tremor. I also consulted him about my migraine headaches, which I had been having more frequently. Dr. Yahr prescribed Cogentin to help with my tremor and Fiorinal III for my migraines. I was still on Symmetrel, 100 milligrams twice a day. As it turned out, though, Symmetrel and Fiorinal III are drugs that I am still using, but Cogentin caused a very dry mouth and interruption of

my train of thought. It is one thing to be speaking with friends and have your mind go blank; it is quite another when you are discussing business with a client.

The deprenyl program started in December of 1984 and lasted until December of 1988. I checked into Mt. Sinai Hospital on 11 December for a week, at which time I was taken off of the Symmetrel and Cogentin and after three days started on the deprenyl.

Deprenyl was given in this study to patients who were not on Sinemet (dopamine) in the hope that it would lessen the need for Sinemet for a prolonged period of time. It was also felt that the deprenyl would keep the Sinemet dosage, when finally administered, at a lower amount for a prolonged period of time. It turned out that I was one of the latter patients.

Mt. Sinai is a teaching hospital, and I felt like a prize guinea pig. One of the doctors was a very acerbic Asian woman, dedicated and difficult. The second morning I was there a group of internists arrived at my room and the "acerbic Asian" was in command.

"This is Mrs. Grady and we are going to take her off her medication and we will then do a spinal tap to check her dopamine levels, put her on deprenyl and in three days do another spinal tap."

I was too stunned to say anything as they exited the room, but when I regained my composure, I called the head nurse. "I wasn't told by Dr. Yahr they were considering a spinal tap. They are somewhat dangerous and very painful. I think I have wasted everyone's time, so you better inform Dr. Yahr I will be leaving," I said, visibly shaken and afraid of what else they might have in store for me they hadn't bothered to share.

The head nurse, a sensible woman, must have shared all of this with Dr. Yahr, because I went through some interesting tests and the spinal tap was never mentioned again. However, the "acerbic Asian" happened to be the head of the deprenyl program, and this would be the first of many differences of opinion with her.

The week that I spent incarcerated at Mt. Sinai was frustrating. Being taken abruptly off my medication made my tremor worse and my ability to concentrate almost impossible. I ate, walked the halls, rode the exercycle, and tried to communicate with some of the other patients, the majority of them in very hopeless conditions.

One lady, who had Alzheimer's disease, occasionally walked with me. "You know I used to be a first grade teacher. I am married, have a grown son, and a grandson, but I am sick—I can't remember sometimes." There were

times when I would meet her in the hall and she would say, "You know that I live around here, but I can't remember where. Would you please take me home?"

Another woman with Parkinson's used a walker and had a great deal of difficulty speaking. I realized that this was a person imprisoned in her own body and that if I weren't extremely lucky this would someday happen to me. The thought was terrifying.

Two of the tests I underwent were fascinating. One involved a machine that, somehow, measured the amount of time that elapsed between the eye seeing an object and the brain recording it. Another did the same for a sound being "heard" by the ear and registered by the brain. My test results, thank goodness, were normal.

Dr. Yahr and I discussed the fact that I planned on checking out of the hospital on 18 December, going back to the farm for several days, and then going to England to spend Christmas and see my newest grandson, Andrew. Dr. Yahr didn't think it was very prudent for me to travel alone to Europe on a new experimental drug. I thought it would be a good test and finally convinced him that I would be okay since I was staying with my daughter. What he didn't know was that I had planned a side trip to Paris to visit with my French clients.

One day in the hospital, Dr. Bergman was making rounds, and I told him about my plans and my conversation with Dr. Yahr. He was amazed. "You negotiated with him! Dr. Yahr doesn't negotiate with anyone. He must really think you're special."

I don't think that Dr. Yahr liked me any more than his other patients. I do think that I had earned his respect. On my second visit I told him about the farm—that I planned on moving to North Carolina to try raising Arabian horses. When I moved to the farm in July of '83 in spite of my Parkinson's disease, it impressed him. Either that or I amused him or he thought I was totally crazy. I suspect it was a little of each.

Cheryl and Me

Born on 6 August 1955 in Chitose, Hokkaido, Japan, Cheryl came into this world as close to being a perfect child as any parent could have asked for. She slept through the night when she was three weeks old, walked at ten months, and talked at two in complete sentences. She always believed me when I threatened to put an ad in the newspapers to find the children a new mother when they were misbehaving—Claudia and Bobby never did!

If there were only two sticks of gum, she would say, "Give them to Claudia and Bobby or they will fight. I don't need any."

Cheryl was the most popular girl in her class in the sixth, seventh, and eighth grades. She was an above-average student, studied concert piano, and was a superlative rider. She won the award for the most points in the 15–17 equitation and attained overall high score for

points in the state of Florida in 1972. She was a trouble-free child.

When she decided to move to North Carolina with me, I suspected that she had discussed this with Claudia and Bobby and they had all decided it would be a good thing for me not to go to North Carolina alone.

Our first minor problem was Goliath. He had made several trips with me to the farm and was such a seasoned traveler that he roamed loose in the car. He would sit on my head rest as I was cruising at seventy-five, flicking his tail in my face as we passed other cars as drivers gawked at us.

When we arrived at the farm, I decided that Goliath had forty acres to relieve himself on and didn't need a litter box. But he decided that he was a "city kitty" and city kitties did not go to the bathroom outside. He would be outside playing with the barn cats and say, "Wait a minute guys," cry to come in the house, use his litter box, and then go back out to play.

I took a firm stand and removed the litter box. I put it on the porch. However, I did not win this battle.

Cheryl served as the intermediary when the upholsterers set my favorite newly upholstered chair down in the living room and Goliath marched right over to it and re-

lieved himself. Cheryl flew to his rescue, "Now don't hurt him, Mother."

"Don't hurt him? I'll kill the little son of a bitch." But he made his point and the litter box remained in the bathroom all my days on the farm.

Cheryl worried about my fearlessness with strangers. We had a shotgun that she tried to teach me to shoot, but she decided after a few sessions that a shotgun in my hands was a lot more dangerous than the weed whacker.

I, of course, felt no one would ever get past my mouth. Most of the time I was secure with that. The few times I had an attack of insecurity, I could always count on Leonard, who was only a phone call away.

Cheryl vowed to live on the farm forever, but I knew it was just a matter of time before she would want to strike out on her own. She went on vacation in July of '84 and renewed an acquaintance with a son of one of my friends. They discovered that they really liked each other and wanted to try living together.

When Cheryl departed, in September, we had in residence on the farm a dozen and a half chickens; our rooster, Norman; Scarlet and Ashley, grey pilgrim geese; Wilbur, a white turkey gobbler; Julie; three barn cats; Goliath; and Eli. We had made it through one of the coldest win-

ters on record in western Carolina relatively unscathed. Eli was his sleek plump self with a chestnut coat full of dapples glistening in the noonday sun. But our biggest accomplishment was earning the respect of the country people.

I would miss Cheryl terribly. We were more like two good friends than mother and daughter. The relationship was very symbiotic. She gave me strength and I gave her courage. I knew surviving the second winter alone would be an even greater challenge, particularly since Evelyn had moved into town to be closer to her daughter, and Leonard's farm was over a mile away.

Europe

On *the morning of 23 December 1984, I left the farm* at nine A.M., which meant I had to get up at six A.M., get a quick cup of coffee, swallow my deprenyl pill with a little juice, feed all of the animals, and drive an hour and a half to get to the airport. I had no time for breakfast at the Asheville airport, and when I got to the Charlotte airport I didn't eat lunch assuming that they would serve lunch on the flight to New York—WRONG! However, I did have a cola and swallowed another pill on an empty stomach. We were in the holding pattern at Charlotte for close to an hour before we took off, so it was about three when we landed at Kennedy airport in New York. I was carrying my full length fur coat, a "Teddy Ruxpin" singing bear for my grandson, a carry-on bag, and my purse. Now this was no small task for a lady with Parkinson's disease who had been up since six taking medicine all day on an empty stomach.

I had a habit of not eating when I was busy, but this was a habit that I had to modify quickly because I had to eat when I was taking my medicines. I would take my medicine and then eat. The medications are absorbed in the small bowel, and a Parkinson's patient burns a lot of calories.

When I disembarked at Kennedy, I had to take the shuttle to the other side of the airport, where international flights departed. I elected again not to eat, because I wanted to know I was in the right place to board the plane, and then I would eat. When I finally arrived at the terminal there was nothing to eat and they were already starting to board. The lady standing behind me in the check-in line was munching on some cheese crackers. I stared at her.

"They look so good," I said, trying not to drool, and she graciously gave me two. I thanked her profusely, but I don't think she knew to what ends I would have gone to get at those crackers.

Shuttle buses carried the passengers from the terminal to the airplane out on the tarmac. I squeezed into the second shuttle with a seething mass of humanity all bundled together, body odors intermingling as all races and

creeds gathered with a common goal, going home for Christmas.

When we finally boarded the airplane, it was about five o'clock and I knew that we wouldn't eat for at least an hour, but with any luck drinks would be served soon after we took off.

"I'll have a double martini please," I said nonchalantly, but the stewardess glanced at my shaking left hand and gave me the stare that I am certain she reserved for alcoholics, not knowing she was looking at a starving Parkinsonian.

If nothing else, Parkinson's disease has taught me humility. Having downed my martini, I was pleasantly relaxed by the time dinner came and had stopped shaking. I was one of those people in which alcohol stopped the tremor. It's a good thing I was not addicted to alcohol; over the long haul, moderation has always been my guideline.

We arrived in London at 7 A.M. the next morning, and my luggage was not on the plane. It arrived the next day, just in time for Christmas.

Andrew was precious. He loved his talking bear and carried it everywhere with him. Children make Christmas

an enchanting time. Claudia was pleased with the way I looked and moved. She didn't see me every day and was very sensitive to any subtle changes.

This had been my first major trip since I had been diagnosed, and I realized that I would have to modify my traveling habits to fit my health or I would stay in a constant state of turmoil when I traveled. This could be avoided with a little advance planning.

When I went to Europe some little voice inside of me said take your Symmetrel with you in case things don't go well. It turned out to be a very good idea. I started to have the symptoms before Symmetrel: loss of energy, more tremor, and general loss of dexterity, so I put myself back on the Symmetrel and it solved my problem. I was a little concerned that Dr. Yahr might be upset about this and drum me out of the deprenyl program, but I decided to have an enjoyable trip and worry about the consequences at a later date, an attitude that has caused me both a lot of pleasure and pain in my life. It's called the "Scarlet Syndrome."

Midweek we drove into London and saw *Evita*. I stayed in a London hotel that night because I had to catch an early plane to Paris the next morning. After the theater, I had a terrible migraine and finally wound up taking two

Fiorinals in about a three-hour period, but woke up with a clear head, for which I was grateful.

My French clients' chauffeur met me at Orly with a sign saying "Grady." He took me to Arman's offices. We had lunch with Mounir, his financial advisor, at a quaint Greek restaurant and discussed business over lunch. Arman and Mounir both knew I was ill, but it was never discussed, because they knew my mind was working and that's all that mattered to them.

That evening Arman and Cecile had a dinner party for me at their flat in the seventh district of Paris, with about ten guests. He was one of the largest caviar importers in the world, and we had a seven course meal including caviar.

The next evening, I went out to the Lido, a famous French night club, with Christian, Arman's first cousin, and his wife Katrine.

As I was airborne coming back to England the next afternoon, I thought about what a stunning time I had in Paris and how well I felt. Claudia and my son-in-law Bob met me at the airport and we had dinner in London in a well-known seafood restaurant.

Claudia had several couples in for New Year's Eve, and we all celebrated the new year.

On 2 January 1985, after a tearful farewell, I reluctantly said goodbye to Claudia, Bob, and Andrew.

Back in the United States, I called Dr. Yahr and explained what had happened. To my relief, he wasn't angry and I continued taking the Symmetrel.

Farm in Winter — Alone

Strength *has different levels, and after Cheryl left I dis-*
covered she had put up with a lot of inconveniences in
taking care of the animals. For example: carrying water
down the steep bank to Eli's stall was very hazardous in
good weather, but in snow and ice it was awesome if you
came back alive. Again, I thought I was fit, only to dis-
cover that I needed to be more fit.

At the upper part of the farm, about a half mile uphill,
we had foolishly stored our hay and shavings in the old
barn that belonged to the original farmhouse. We did not
try to renovate this house because it wasn't structurally
sound, but the barn was sturdy and eventually I had
planned to build a new house on this site and renovate
this barn.

One day the sky was full of snow clouds and I needed
shavings and hay, but I had been getting firewood from

the woodshed with the truck and stacking it in the wood holder on the deck preparing for the storm, and time got away from me. It was difficult enough to drive the truck up that steep road on a clear day and impossible for me on a bad day. So, dressed warmly, I started out pulling our Vermont cart (wooden wheelbarrow) up the hill to the upper barn. Wind was whipping through the valley at a frantic pace and the snow was stinging my face. With each step the cart seemed to get heavier and heavier until I was sure it weighed at least a thousand pounds. Julie was bounding ahead of me, stopping impatiently occasionally to see if I was still moving. "You know," I said to myself, "you could be in Miami in a climate-controlled environment, but you have chosen to drag a cart up a mountain in a snowstorm." And I thought, "Better to die with the wind whipping my face than an oxygen tube up my nose." I looked up and the barn was in sight. Inside the barn, I enjoyed being out of the wind and caught my breath before starting to shovel sawdust into plastic bags. My foot hit a piece of tin roofing in the dark barn. I slid to a sitting position, Julie licking my face. "You know, Julie, a person could hurt herself if she were not careful," I said, laughing at myself.

Going down was much easier than going up. I reached

Eli's shed, fixed his stall, and fed him some hay with a great sense of accomplishment.

When I got back into the house the phone was ringing. It was Leonard. "It's supposed to get very cold tonight and they're wanting more snow. Are you going to be okay?"

"Yes, we'll be just fine."

It continued snowing the rest of the day, and I blanketed Eli when I fed him that night.

When I went to bed, the temperature on the outside thermometer was reading zero. I had the heat strips on in every room and a fire in the fireplace. I turned off the kerosene heater in the kitchen when I went to bed. Julie refused to come in and was nestled in her doghouse on the back deck; all three barn cats snuggled in with her.

I had on my long underwear and socks when Goliath and I slid under my electric blanket and went quickly to sleep.

The glare from the sun reflecting off the snow in my bedroom windows woke me up. We had gotten at least two feet of snow and there were drifts of at least four feet.

The thermometer read twenty below zero.

I lit the kerosene stove, put the water on for coffee, and started a fresh fire from the embers in the fireplace.

Julie came in and had coffee with me. It was about eight o'clock. I put on two of everything, took a deep breath, and opened the back door. Julie, who loved snow, went racing out ahead of me, running in circles, chasing her tail.

The moment I saw Eli, I knew he was in serious trouble. He was on the bank about one hundred feet above the house. His blanket was turned around and under him so that he couldn't move without stepping on it. I knew that if I signaled Julie to get him, she would run him off his feet, so I chose to climb the bank and fetch him myself. The footing was treacherous as I slowly made my way up through the snow.

On his down side I tried to right his blanket and comfort him. He stared at me through frozen lashes as I tugged on his blanket; it wouldn't budge. "It's going to be all right, Buddy," I said, fighting back tears of panic. I moved above him and said, "Please, God, I need a little help here," knowing that a well person could have moved the blanket easily. I gave the blanket a final tug and, to my surprise, it righted itself.

I walked beside Eli as we came down the steep bank and realized that if he fell it would be on top of me. At that instant I lost my footing and tumbled down the bank

about ten feet into the soft snow. Julie, thinking it was a game, started barking at me and licking my face. Meanwhile, Eli continued down the bank toward his stall and, as he rounded the corner below the kitchen window, he fell down. By this time, I was on my feet again and watched him struggling to get up. Finally with one powerful lurch, his hind legs got enough traction in the snow to lift him. He went to his stall. We had deliberately not put a door on his stall so that he could come and go as he pleased. His grain was frozen. I broke up the chunks with frozen fingers, and then gave him some hay.

My experience has been that animals do just fine in cold weather as long as they get plenty of food and water and have a place to get out of the wind.

My next chore was to take a hammer and break the ice out of all the animals' water buckets and to feed everyone. By the time I was done, my hands ached so fiercely that I went into the house. I ran them under warm water and then continued my chores. Leonard could get to me in an emergency when it snowed, by tractor, but with the temperatures so low, the diesel fuel would be frozen, so I was truly alone. Just knowing that I was responsible for all of my critters took me out of myself. It gave me an inner strength.

Leonard called about eleven. "Are you okay?"

"Yes, I'm fine. I had an uneventful morning," I lied.

After the snowstorm, I made elaborate plans to finish the barn. I put in a washroom and installed a hot-water heater, built a tack room, and put trap doors in the hayloft to throw the hay down without going outside. I had to walk three hundred feet instead of twenty feet, but the barn was safe ground once I arrived.

It's a challenge to try to explain the majesty of this land. The farm dead-ended into about four hundred acres of untouched forest ranging from an altitude of twenty-eight hundred feet to thirty-two hundred feet. I had the beauty of absolute privacy. There were rare Chinese chestnut and black walnut trees, waterfalls, and two creeks that looked like dark ribbons in the snow. The trees appeared like giant spider webs. It was here that I understood the "beautiful sound of silence." Walking the mountain road which formed the boundary of my property became a part of my routine in all seasons. It was about a mile and a half steep up, curved around and then came steep down.

My Parkinson's disease became such a part of me—I assumed everyone had some affliction or some problems and when someone looked at me in awe over my accom-

plishments in spite of this usually crippling disease, I would say, somewhat embarrassed, "Everyone has something that they cope with. Perhaps I have more than most, but as long as I can function I will be okay. I try to be like a mountain climber; I don't look back and I never look down."

February was bleak and cold, but I found myself enjoying the solitude. Curled up by the fireplace in my father's overstuffed chair, a good book in hand, with a glass of brandy—I felt secure and at peace with the world.

In my continuing search for Arabian horses, I was introduced to a man named Hershel Williams, who had a farm in Leicester. One day I went over to buy some alfalfa hay from him.

"I've got a nice Arabian mare I'll sell cheap," he said. Hershel was a real wheeler and dealer, but he was always honest with me.

I laughed. "What's wrong with her."

"She's old. She's twenty-five. But she's really a nice mare. Gentle as they come. She's grey and she's bred to Apache, my Arabian stallion. Arabians live to be thirty-five."

This peaked my interest, and I asked, "Can I ride her, right now?"

"Right now? Sure why not?"

Hershel brought her out of her stall and saddled her up and I climbed onboard, thinking to myself, "You don't know this man very well and this horse could be a maniac and here you are one foot in the stirrup already." I walked her first down his dirt road and then I trotted and, much to my surprise, I cantered her. Hershel was right, she was very gentle. This was a very brazen thing for me to do because Cheryl usually rode the horses we were considering, but she was gone and I was very pleased with myself. Several days later, I had her vetted out and she became the second equine resident at Hyperbole Farm.

The day she came was like an answer to Eli's prayers. He had been gelded late in life and had a lot of studdish characteristics. He fell in love with Araby at once.

..

Renewal

I watch the dawn appear
like a sulky maiden
lurking in shadows.

Animals are thick with coat
snakes shed their skin
and crabs' shells soften.

Chickens molt
and trees abandon
their leaves
as snow dresses
the naked ground.

I walk on frozen pond
and leave my dreams to sleep
as dusk rushes into dark.

Another year passes
and trespasses into
a new birth.

Fowl Play

W*ilbur was one of three white baby turkeys purchased*
at the feed store by Cheryl. One was killed by a weasel,
one got sliced up by a sickle, and then there was one,
Wilbur. He was raised with the chickens in the corn crib,
but when he got big he roosted on the deck. He patrolled
the deck in the daytime when I was in the house, admir-
ing his reflection in the French doors, and followed me
everywhere when I was outside.

All of my animals ran free on Hyperbole with the ex-
ception of fencing to keep the horses home, but they had
forty acres to roam on. Wilbur was no exception. One
night I had guests for dinner and we were having cocktails
on the deck. Wilbur sauntered onto the deck and began
munching on the potato chips. He seemed very inter-
ested in our conversation. He was such an elegant bird

that I was always wanting to get him a black bow tie and some spats.

As he got older he became completely devoted to me and started to get very possessive when other people came to visit. If you have never seen a thirty-two pound turkey hurl himself into the air and hit a human being in the chest with his talons and come crashing to the ground, it is an awesome sight.

Wilbur eventually became so possessive of me that I was afraid that when one of my grandchildren came to visit, he might knock one of them down and injure them. So one weekend when I was going away I had Leonard come and get Wilbur. I just know that he went to that great turkey heaven in the sky and is looking down on me now, thinking too much devotion is a dangerous thing.

We had two pilgrim geese I had named Scarlet and Ashley. They were adult geese when they came to live with us the previous spring, and they were mean. I would go to their temporary pen to feed them and they would come at me wings extended eight feet and mouths open. Fortunately for me, I had dealt with geese before and knew that intimidation was their game. I showed no fear and smacked them on their bills when they attacked me.

Soon they became very tame, but they were still hostile to strangers, which made them excellent watchdogs.

I bought them a plastic kiddy pool about five feet in diameter and two feet deep. They knew the minute I set it down that it was for them. Getting a running start, wings extended, they approached the pool as if it were Lake Lure, tiptoeing across the water. Then they would get into the pool, preen themselves, and turn somersaults in the water. It was particularly comical when they were in the pool together.

Late one afternoon, as the sun splashed on the deck making intricate shadows, I sat on the deck steps drinking tea from one of my tall yellow cups. Even the creek seemed to hush. Scarlet and Ashley were preening themselves on the front lawn. Scarlet became curious about my cup. She climbed into my lap making her little happy sounds and sipped tea with me. Ashley, who was never as friendly as Scarlet, looked on in disdain.

At one time on Hyperbole, I had two dozen chickens. Leonard suggested that we move the chicken coop that was behind the house at the edge of the woods to a spot adjacent to the barn.

We had been keeping the chickens, who roamed freely

in the daytime and roosted at night, in the corn crib below the house.

I was very excited about having a real chicken coop. We made nests and they all went in there to lay their eggs, and they roosted in there at night. I could close the door and they were relatively safe from predators, but the attrition rate on chickens in the mountains was very high. After a while, I was up to my ears in eggs and sold about three dozen a week to the local market. I never ate my chickens, however, even with Julie patrolling the farm, everything else did.

There are a lot of parallels between people and animals, but I find animals a bit more constant.

..

Farm in Spring

A *friend of mine who lived in Ft. Pierce, Florida, called* one day in March and said, "I'm getting out of the horse business, and I wondered if you would like to buy Bay."

Bay was an Arabian gelding I had ridden when Jackie first got him when he was five. Now he was ten. We had ridden for about two hours that day and Bay had been a perfectly well-mannered, well-trained, and very pretty Arabian. I was excited. We decided on a price and they shipped him to me in April. Now we had three horses on Hyperbole farm.

With three horses now, I had to have more of a routine than I did with just two. The barn was finished. There were four stalls and a tack and feed room. I found out very quickly that Eli picked on Bay, and that Bay had a victim-type personality. The horses had their meals in their stalls and in nice weather they were turned out—

free to roam. They were fed morning and night. Julie needed very little training to help me herd the horses and the chickens as she was born with the herding instinct. I taught her the basic commands—stay, come, leave it, and go get them.

She was a very valuable asset to me, and Leonard was very impressed that I had picked such a good dog.

In rainy or exceedingly cold weather or snow, I kept the horses in at night. I also kept them in if I wanted to go riding so that I wouldn't have to catch them.

The vet showed me how to give worm medicine and intramuscular shots. It required a great deal of dexterity to perform these tasks on a thousand pound animal who didn't necessarily want to cooperate, but I persevered until I became fairly proficient at it.

Parkinson's is as much psychological as it is physical.

It requires a great deal of agility to put on a bridle. You have to put the reins around the horse's neck, one hand grasping the headstall and the other hand inserting the bit using your thumb and forefinger to pry open the horse's mouth, while sliding the headstall over his ears. Even a well person could lose a finger if he or she weren't careful.

On good days, it was very easy for me to perform these

tasks. I almost never had a bad day when I was alone and there was no one else to help me. However, when my daughters, who were very proficient horsewomen, came to visit, I was all thumbs.

I became fascinated with the capriciousness of the disease and tried to make some sense out of it. I seemed to do better when I was alone or when I was with an animal or a child that was dependent on me and worse when I was around somebody who was physically competent. I was also better around the people who didn't know that I was ill. But to this day I still haven't been able to sort it out. I take advantage of the good days and endure the bad ones.

In April, I was invited by Lainie and Durward Grady, my former sister- and brother-in-law, to Stoneybrook, an annual steeplechase outing in Southern Pines, but plans were canceled at the last minute because Lainie had to have surgery. Durward had introduced me over the phone to Ed Fitchett, an architect friend of theirs from Asheville, who was going to drive me to Southern Pines. We had several telephone chats before the weekend was canceled.

In May, Claudia and Company, my youngest daughter, her husband, and my grandson Andrew, arrived from Eng-

land for two weeks. I had been invited to a dinner party in Asheville and didn't want to go unescorted. I picked up the phone and sight unseen invited Ed Fitchett to escort me to the party. Claudia looked worried, "Aren't you the least bit concerned what he looks like?"

"Well, he is one of Lainie and Durward's best friends and he's an architect. How bad can he be?"

We agreed to meet in the lounge at the Inn On The Plaza. I told him I would be wearing a white dress and he said that he had a Van Dyke beard. I was feeling good about my appearance when I walked up to the table where he was sitting. I smiled and said, "Hi, I'm Joan Grady and you must be Ed."

He smiled, his blue eyes intensified by the blue in his linen jacket, his Van Dyke beard balancing out his sparse grey hair. He looked directly into my eyes. "Yes, I am." I knew we would have a good evening.

The dinner party was at the City Club; there were at least seventy-five people there, plus a band. Ed knew a lot of people and he moved easily through the crowd with me. I felt as if I had known him all of my life.

After the party we went for coffee and talked about being divorced parents. He had two children, a daughter and a son. His children were younger than mine. His son

was living with him. He asked me how I was feeling and I knew that Lainie and Durward had told him about my Parkinson's. It was a pleasant evening, but I was not smitten with him, just comfortable.

As I made the hour drive home I wondered how normal I really looked to him and if he found me attractive. I had not allowed myself the luxury of thinking I would ever find a man who could fall in love with someone who was ill. I wondered if I would hear from him again.

...

Tragedy Strikes

A*raby's foal was due in June. That was the date that* Hershel had on his calendar, and I took his word, but what I didn't know was that she had been running free in the pasture with the stallion and had actually been bred the month before.

Andrew had cried off and on all night and Claudia had been up and down with him. With all of the confusion in the house, I wasn't aware of all of the outdoor sounds. Coffee cup in hand, I walked down to the stable early that morning and Araby was standing by her feed bucket with the head of the foal hanging out of her. I blinked and it was gone. I waited for another contraction and felt the head and it was the temperature of death. God only knows how long she had been in labor. The foal was dead and I realized that if I didn't act swiftly, I would lose Araby too. Fortunately I had installed a phone in the tack

room. I called Bill Weber, a veterinarian-neighbor, and he and Bill Jr., also a vet, came immediately. It took them an hour to remove the dead foal in its position from Araby. In a normal birth, the front feet come out first followed by the head, and the shoulders contract in this normal position, but Araby's foal's head had come first and the shoulders were too wide in this position to get through the birth canal. It took Bill an hour to push the foal back into the uterus between contractions and pull the feet forward to remove it. He was a large handsome colt, black, with a white strip on his head. I often wonder if things had been different, if he had lived, what he would have been like. Leonard buried him under a chestnut tree. Some nights when it was very still I would listen for his tiny hoofbeats.

You cannot survive on a farm with animals and not be aware of death. It is a natural phenomenon. I never was comfortable with it, but I accepted it, confronted it, and made my peace with it during my eight years on the farm.

Leonard

I*f I compared the farm to a large concrete building,* Leonard was the cement that made it all come together.

Leonard was Loy's first cousin. He and his son Ronnie worked for me for about eight years without a cross word, which tells you something about our relationship. Leonard was not like Loy. Loy had left the mountains to serve in the army in Europe. He was very gregarious and didn't know a stranger. Loy put me through all of his tests of character. I passed and we were close.

Leonard was shy and at first somewhat more leery of me than Loy. Leonard's tests were more cautious, and he didn't let his guard down all at once; it was a gradual thing. When we were finished with the barn and I had three horses, he said one day, "Me and Ronnie don't want to work none with horses."

I studied his face carefully and knew all of the hours he

had put in on the house and barn and how proud he was of them both. "Leonard, you think about it, but I don't want you to saddle and groom the horses and keep the stable clean, that's my job. I just want you to feed them when I travel and do the things that I physically can't do."

He smiled back at me, "I think me and Ronnie can do that." I knew I had passed the last test. When there were crises, I always knew I could count on Leonard.

We had a small Nissan pickup truck. It didn't have four-wheel drive, and I managed to get stuck about everywhere on the farm. That truck wound up in ditches, creeks, snowbanks, and mud. I would walk home from wherever I was and call Leonard, and he would always retrieve it for me. After I had been on the farm for several years and had really learned to drive that truck in all seasons, I said, "Leonard, I haven't gotten the truck stuck anywhere for at least six months."

He laughed and said, "That has to be some sort of record."

When Leonard had some work to do for me or when he wanted to discuss future work, as we always had projects going on, he would come to the house after he had finished feeding his own animals, which was about eight A.M. We would sit at the kitchen table, have "sudden cof-

fee," and discuss the problems of the world. He had told Cheryl, "Your mother is the thinkingest woman I ever knew."

His life was centered on the church, and he practiced being a Christian every day. The country people admire anyone who works hard and minds his own business. Leonard admired me and my courage to live alone on a farm, a mile from my nearest neighbor.

He knew that I had Parkinson's disease and knew what it usually did to people. He was fascinated that I stayed so well. At this time I was on Symmetrel and deprenyl. Symmetrel was also used in the prevention of the type-A flu and brain trauma with concussions. I think that having been on Symmetrel has kept me from the common cold over the years.

The animals, particularly Scarlet and Ashley, loved Leonard. Leonard was the only one I ever saw who could pet Ashley. Leonard had raised animals the country way and "didn't pet on them," but he got very attached to my animals and was very caring with them.

..

Farm in Autumn

Hyperbole, *in fall, looked as if God had taken a paint* brush and colored all of the leaves. In the fall of that same year, I saw Ed again. Sunday morning the phone rang. "Hi, remember me, Ed Fitchett? It's such a pretty day, if you're not busy, I thought I would drive out to the farm."

I hesitated and said, "Well it's been a long time since I've heard the sound of your voice, but you're right, it is a glorious day. I'll have to give you directions or you will never find me."

After giving him directions I hung up the phone feeling a little hostile. Architects can be very critical. He was probably just bored and looking for something to do.

He arrived just after noon, and I didn't offer him lunch. We roamed all over the farm, splashing in the creeks and challenging the steepest hills. Ed inspected all of the old out-buildings, including the original farm house. I took

him to my private place where the water cascaded down a huge fifteen-foot boulder falling into a small basin below. Pale green lichen wandered aggressively over the craggy rocks at the edge of the pool sheltered by winter green ferns. For some reason that I couldn't explain, I felt like sharing with him my thoughts and future plans for the farm. I suspect that Ed fell in love with the farm that day, long before he fell in love with me.

When it was time for dinner, he was still at the farm and I asked him to stay. The conversation was easy, but he was very guarded about himself, making only one reference to our getting together again, which I didn't take seriously. At about nine o'clock he left. I had enjoyed the day, but I still wasn't smitten with him. Perhaps because the likelihood of his getting involved with someone with Parkinson's disease seemed pretty remote, I didn't want to get my emotions all revved up to be disappointed.

He didn't call. I did not see him again for four years.

Farm in Autumn

Coarse grasses bend
beneath my feet
as I ascend the
overgrown path.

Abandoned farmhouse
windows long gone
looms on the hill.

Wind-captured leaves
flutter like
Swallowtails and Monarchs.

Chinese chestnut tree
still green
extends long arms and

relinquishes its fruit
to hungry squirrels.

Pastures lie fallow.
Orchard grass, fescue,
briars and weeds
vie for dominion.

Rushing downhill
the creek whispers
over porous rocks.

At the edge of the woods
I listen
as a Grouse drums his wings
calling his mate.

..

UNC Asheville

In *January of 1985, I decided to take a creative writing* course at the University of North Carolina in Asheville. I had not been back to school for twenty years, and I was tense and excited. I went through enrollment, standing in one line after another, getting my student I.D. card with my picture on it, trying to look normal.

We conjure up things in our minds the way we want them to be, and when they are not, we panic. The class instructor's name was written on the schedule as J. H. McGlinn, and I naturally assumed it was a man. When I arrived at class early and saw a woman, I was surprised, but she seemed to have a very kind face and a sensitive demeanor. I swallowed and sat down. There were three other adults in the class, but I was the only woman and the oldest.

Jean McGlinn was in her thirties. "I want all of you, in

the next twenty minutes, to write about an incident in your life," she directed.

I froze. My handwriting left a lot to be desired. I could write slowly and make it legible, but it was very small and didn't look normal and I so much wanted to be normal. There was a cup of hot chocolate sitting on my desk. I moved the wrong way and it spilled all over my notebook. I was almost ready to cry when that little voice inside me said, "Get a grip on yourself, Joan, you can handle this. First clean up the chocolate mess and laugh about how clumsy you were. Write something down on your paper, even if it's wrong. When you leave the class and turn in your paper you will say to Mrs. McGlinn, 'I have a neurological problem with my left hand, I hope that you can read this. I didn't realize we would have to write in class.'"

Jean McGlinn smiled up at me, took my paper and looked at it. "I can read this, there is no problem."

I started writing a daily journal and coped with writing in class, but the most significant thing that happened was that Jean really liked my writing and encouraged me to continue. We became friends, and I got an "A."

I audited one class the next summer, then sent for my transcript from college and considered working toward

finishing my degree. In the fall, I enrolled in two classes, English Literature and French. This time, I decided to take the classes in the daytime which, with all of my farm chores, was no small undertaking. Learning is wasted on the young because you appreciate it so much more when you are older. I was having a grand time, even with Parkinson's disease, when fate stepped in and my life was put on hold.

..

Law Suit

In October my monthly rent check from Miami didn't arrive, and it had never been late before. This was one of my main sources of income, from a long-term lease inherited from my father. It was an extremely valuable property. I called the lessee. They informed me their corporation had declared a chapter eleven bankruptcy. There would be no rent check until this was straightened out, and it could take as long as a year. They admitted they had not sent me notice. I called my attorney in Miami and my brother, who was also an owner in the property. After talking to them, I knew that the situation was critical and that if we weren't careful or very lucky, we could lose this property. I had negotiated this lease for my father and it was a good tight lease, but chapter eleven (reorganizational bankruptcy) was a specialized field, and we would have to get an attorney who specialized in that field.

I made arrangements to leave my safe mountains and go to Florida to fight for what was mine. On the plane to Miami, I stared out at the wings and wondered if I could still fly.

I had been involved with enough real estate over the years to realize that if T. Corporation sensed any weakness on my part they would move in for the kill. At all costs I would have to present myself as a normal person. It was my impression that during the last ten years this corporation had tried to cheat us. In those ten years, the property had gone from $250,000 to $3 million in value. The lease had twenty years to go.

One of the first things I did in Miami was arrange for a hefty line of credit so that we would have some funds. My brother and I retained an attorney, Robert R., who also happened to be my personal attorney, and a bankruptcy attorney.

At our first meeting with George N., the bankruptcy attorney, after a few polite questions I asked, "We have a very good lease and T. Corporation appears to have breached it by not sending the rent and not giving us notice; what is it going to take to break this lease and get us our property back?"

"Mrs. Grady, it is going to be very difficult to break this

lease, but it can be done." This was a chance to separate my affairs from my brother's and be really free. It appealed to me. Selling my brother on the idea was quite another matter, but I finally prevailed.

I knew that I would be in Miami a great deal more than I had originally planned. I couldn't impose on Billie Turner, so I leased a small apartment and some furniture and began a double life.

My meeting with the president of the bank to arrange the line of credit was over lunch. When I dined with a client or banker I was always careful to order only things that didn't require a lot of cutting as I couldn't depend on my left hand and it was better to be safe than sorry. I was always dressed in the latest casual fashion with my nails perfectly polished; I was a great deceiver. Bankers and clients get very nervous when they try to discuss business with someone who looks ill.

...

Depositions

I tried to arrange my schedule so that I would be in Miami for about two weeks and back on the farm for at least a month. However, this was not always possible.

The process of discovery involved a lot of depositions. Deposing someone is just another name for interrogation. It can last for one hour or days.

T. Corporation's major stockholder and the chairman of the board of directors was Richard B., whose family owned a very valuable patent. We're talking serious money here. We had two attorneys, they had five.

When we arrived at my attorney Robert R.'s offices for the first deposition, the court reporter was already there. She was a plump woman with a round nondescript face.

Today we were deposing Richard B. Sr., whom I had never met. He arrived with his son. Richard Sr. was a dis-

tinguished looking man with a full mane of white hair. His navy cashmere jacket had solid gold buttons on it. He looked too gentle to be an adversary. Richard Jr. was a different breed of cat. He was darkly handsome and a very angry young man, particularly at us. When we were introduced he chided us, saying, "This lawsuit is an outrage. Our family has never been sued; we should have had a meeting and talked about this."

As Robert R.'s interrogation of Richard Sr. unfolded, I began to suspect that they were trying to take this property from us. We had leased the property to a Glenn P., who had a whole chain of stores. Richard Sr. had financed this endeavor. In order to gain controlling shares of stock in T. Corporation, Glenn P. had sold some of his best leases to T. Corporation. Our lease was one of them. This meant that Glenn P. had to pay us for leasing our property and T. Corporation because he had sold the lease to them. This was very profitable for the first ten years because the lease was on a fixed income. On the eleventh year, the lease kicked into a cost of living index every five years and the rent amounts tripled. When they declared chapter eleven, they expected to frighten us into taking a lesser lease amount; instead we sued them for breaching the lease.

What came out of the deposition was that Glenn P. had continued to pay T. Corporation rent through the end of 1985 and then abandoned the building, taking equipment that belonged to us.

My brother would have taken the lesser lease amount, because he hated confrontations.

For the first part of the deposition Richard Sr. was accompanied only by their junior attorney, but then we took a lunch break and their top trial attorney, rated number one in Martindale Hubbell Trial Attorneys, came back along with the junior attorney. The senior man leaned across the conference table and with what I saw as a wicked grin proceeded. "Mrs. Grady, you think that you're so clever, but we are going to file a motion to have your attorney removed from this lawsuit for a conflict of interest."

Just Richard Sr. and I were in the room when he said this. The attorney left as quickly as he had come and Richard Sr. sitting at the table opposite from me said in a very curious tone of voice, "Who are you?"

I had to stifle myself to keep from laughing out loud. "I am Joan White Grady."

"Oh, you're Frank's daughter. I knew your father." He was obviously pleased with himself for having put

the pieces together. My father had been in the same business.

What the attorney said, disturbed me. I knew that if I got upset with my attorney I could fire him, but I didn't know that the opposition could fire my attorney. When I questioned Robert about this, he stated that indeed if T. Corporation could prove conflict of interest they could have him taken off the case, but he doubted they could prove it. It was just a scare tactic. However, Robert had erratic mood swings, and when he was up we were winning and when he was depressed he thought we were losing.

Somehow I managed to become a master juggler again. Whenever I made the drive up the lane and saw Hyperbole Farm, I knew I was on safe ground. Looking back, the entire year was so stressful that only my trust in the superior force within me kept me going. Some call it God, some karma, some fate, but whatever you call it, it exists within all of us—that little voice that says keep going no matter what. I called it my guardian angel, and he or she worked overtime in 1986.

I had managed to conceal my illness from our adversaries. In fact, I have a theory about Parkinson's disease and stress. In times of stress, the adrenal glands pump a

fluid that is similar to dopamine. As a matter of fact there was some experimental surgery going on in Mexico in the mid-eighties in which they were transplanting part of the adrenal gland into the brain. Though the technique looked promising, it was later abandoned.

I was under so much stress that my adrenals pumped fluid almost all of the time, and I managed to stay well. This personal theory is backed up by the fact that apathy is a great part of the disease and if you succumb to it, the disease will take over.

The year rolled on, and finally it was my turn to be deposed. I decided that it was time that my adversaries knew that I had an affliction.

Their hot-shot attorney deposed me for eleven hours on the first day and three on the second day. In the last hour of the last day I stopped moving my arm and relaxed and my arm started to tremble violently. They knew they would have to negotiate a settlement. A jury would not look kindly on them picking on a lady who was obviously so ill.

My attorney called me the day after I'd returned to North Carolina. "You have to come back down here."

"But I just got home, and I'm tired." I knew our court date was set for some time in July, and the closer we got

to that date without settling, the better our chances for a good settlement.

"You have to come down here right now or I won't be responsible for the outcome of this lawsuit," Robert threatened over the phone.

I didn't go back. After I had been home for several days and had rested, I sat down and roughed out an agreement. I called my brother, read it to him, and sent him a copy.

My brother took it to Robert, our attorney, who read it and said, "They'll never agree to this!"

I called George N., our bankruptcy attorney, and asked him if it would be proper legally to have a conference call between Richard B. Sr. and Jr., my brother, and me. He said there was no problem and arranged the call for us. I presented our offer. They agreed to it, and then it was up to the attorneys to put it in "legalese." This took two days of five hours each and the settlement was ours. We got our property back. They paid us all of our back rents, paid the taxes, and $100,000 of our attorney's fees.

It took four years to sell our property. We had it priced higher than the market, and it was a long time before my brother would consider less. Our final price was less than we'd been offered the first month it was on the market.

Greed is an expensive lesson that sooner or later everyone learns.

In 1986, I formed my own real estate company, sold several valuable properties for my French clients, and leased our property to a large video franchise. It was a busy and productive time.

..

Sinemet

In March of 1986, I made my usual jaunt to New York for my deprenyl checkup. This time Dr. Yahr said that it was time for me to go on Sinemet, which is dopamine, to feed my brain.

I asked him, "Why?"

"Because when I saw you rising from your chair, you seemed not to be as spontaneous. I think you will be more comfortable on the Sinemet, once your body has gotten used to it."

Beginning on Sinemet was embarking on a timed adventure. Sinemet is a combination of levodopa and carbidopa. One penetrates the brain barrier, and one feeds the brain. When levodopa is taken alone by mouth, only twenty-five percent enters the brain, but when combined with carbidopa (Sinemet) it permits a seventy-five dosage reduction of levodopa. However, the ingested Sinemet

goes to all parts of the body, not only the brain. When Dr. Yahr first introduced my body to Sinemet, I went on it very gradually. It took me about a month to eventually be on three Sinemets a day. The medication interfered with my sleep, and I could tell that there was a stranger in my body. However, when I adjusted I became almost normal again. This was like a miracle. My handwriting returned to normal, I had more energy, and my dexterity levels were about fifty percent better. I found that I could function with a lot less stress.

When we started the Sinemet discussion in New York, Dr. Yahr said, "We find that the best effects occur during the first five to eight years, before some of the complicated responses set in. Eventually it will become less effective and then stop working completely."

"If the Sinemet stops working, why can't you just stop taking the drug and give your body a rest?" I asked.

"We have tried some experiments with that procedure and they were unsatisfactory. I am afraid, Mrs. Grady, it's a one-time exposure for however long it lasts."

I looked straight into his eyes. "Dr. Yahr, if I have a choice of being the best I can be for eight years and then having some so-so years, I want the eight good years," I said emphatically.

"I couldn't agree with you more," he said smiling.

Dyskinesia is the most common side effect of Sinemet. Eventually, it causes the muscles of the body to jerk involuntarily, not to tremble, but to have actual muscle spasms. Other debilitating side effects are psychosis, depression, paranoia, and hallucinations.

Parkinson's disease is very capricious and I was very lucky because my body responded to the Sinemet—some patients do not respond.

Dealing with Death Again

In early spring, Araby, a year after losing her foal, col-
icked and died. It was a very painful death for her and
watching her die slowly over a period of three days was
painful for me. When a horse colics, they throw them-
selves down on the ground and roll. It is a very bad stom-
ach ache, and you give them muscle relaxants and
tranquilizers and try to keep them walking.

I called the vet. She was with me from about eight
o'clock until midnight. We had been walking Araby since
about six. She was not responding to the medications,
and the vet took some of her blood and wanted to take it
back to the lab for an analysis. She wanted me to con-
tinue the medications. One of them had to be injected
into a vein. I didn't feel qualified to do that, so at mid-
night, I called Cathy, a veterinary technician, who was

my neighbor and friend. I asked her if she would help me and she agreed to come.

At about one o'clock we finally put Araby in her stall, but she kept getting cast. She would roll over, hitting the side of the stall with her legs and was unable to get up. We had to go into her stall, each of us taking a leg front and rear and pull her over to the other side. When we did this her legs would come crashing down. We had to be sure to get out of the way quickly.

We had to uncast her every fifteen minutes from one A.M. until seven the next morning. At that time we let her out of the stall and she drank some water. I was very glad that I was on Sinemet that night as my body held up very well under all of the lack of sleep and stress. The next night Araby slept on the bank above the house, and I went out to check on her every few hours. The next morning Leonard was mowing the fields around the house and barn. Araby started staggering around and threw herself in the manure pile. I got hysterical and tried to clean off the manure.

I called the vet, "Araby obviously has twisted an intestine. Please come and put her down."

When the vet arrived we found Araby lying dead in

the creek where she had fallen, the water gently lapping over her body.

The late spring of '87 I bought two more horses, an Arabian mare, Sunshine, and a half-Arab pony named Firecrack, who was also born on the fourth of July. We now had three horses, a pony, and Sunshine in foal, bred to a really special Arabian stallion. I had such great expectations for Sunshine's foal.

..

My Left Foot

The early Sinemet years were good years, except for the fact that I developed a limp in my left leg, particularly my foot, and I was in constant pain. I spent a fortune on shoes, and then my left knee went off and I knew it was time to see an orthopedic doctor. He referred me to a physical therapist, who made an insert for my left shoe, and for a time this worked. Climbing in the mountains every day kept a constant strain on this leg, but I was determined not to let it interfere with my life.

My reaction to Dr. Yahr when he told me that the Sinemet was probably causing a lot of my discomfort was anger. "Dr. Yahr, you told me that I could expect five to eight good years and it has only been a year."

"My dear Mrs. Grady, some people are more sensitive to the drug than others."

At this time I was on Symmetrel twice a day, deprenyl twice a day, and Sinemet three times a day. Parkinson's disease is insidious in that it is a relentless foe that erodes your mind, your body, and gradually your spirit. The nearest comparison I can make is the erosion of sand on the beach because of the tides, but the little voice inside of me always said, "Don't give up, life is worth fighting for."

When I first decided to move to North Carolina, I knew I needed some texture in my life. City life was too controlled. I wanted to get my hands in the dirt, build fires, muck out stalls, groom horses, mow my own lawn— do all the things that I had been paying others to do all of my life. At first, something that would take me an hour to do, Leonard could do in ten minutes. My gaining strength was very gradual and took a great deal of perseverance on my part. I was never as quick as Leonard. I would never have his physical strength, but I did have a great deal of his strength of character.

I would go for days without makeup or looking in the mirror. I bought denim coveralls and wore hiking boots. I was free of all social inhibitions and discovered that I liked the new me. When I mucked out the stalls in the

morning with Julie's ever watchful eye on me, my body responding to me, moving normally, I was in control and at peace with myself.

When I first had Parkinson's and I was with people, it was as if I were on stage and they were watching my every move for flaws. I was tense and on guard all of the time. Now, I've learned to cope with being on stage when I am out in the public eye; after all—all the world's a stage! If I moved my left arm subtly and continuously, I could control the tremor. If I was very still the arm would shake violently. I also had to make sure that my arm was swinging normally when I walked. There was a lot to remember. On the farm the animals did not pose a threat to me, and I was at ease.

Even now, if I close my eyes I can see clearly those mornings when I walked to the barn, Julie herding me, Scarlet and Ashley honking their version of "good morning to you," the barn cats mewing around my feet, the horses whinnying to be fed, and Norman crowing.

Parkinson's News

Traveling to see Dr. Yahr every four months kept me abreast of what was going on in the Parkinson's world. In 1982, some young people were found in California who had all of the symptoms of Parkinson's disease in its last stage. They had gotten a bad batch of heroin and when the doctors gave them Sinemet, they responded. There was a lot of excitement in the medical world about this discovery, because if they could create Parkinson's symptoms then they could work with laboratory animals to control those symptoms. They did experiments with monkeys, whose nervous systems are similar to the human system.

At about the same time in Sweden, a doctor experimented first with monkeys then with humans, transplanting healthy fetal tissue from aborted fetuses into the brain of a Parkinson's patient. Their results were guarded,

but encouraging. There was a lot to learn about where in the brain to put the cells, how many cells to transplant, and whether the patient's body would reject the cells without anti-immunization drugs.

There was a great deal of discussion about this when I was in New York in '86. When I inquired about it, Dr. Yahr said it was still in the experimental stages and that patients would be at great risk. He felt that we should wait and see the progress of the experiments.

Dr. Yahr and his associates had a term for the medical breakthroughs that were reported in the papers. They called it "newspaper medicine." He said it was almost always inaccurate and dangerous because it gave people false hope, but I knew that they would keep working on the fetal transplants. I promised myself that one day I would have this surgery.

Meanwhile, I still made my visits to New York, and one of Dr. Yahr's associates would do my workup, which consisted of taking blood, checking blood pressure and weight, checking reflexes and balance, and assessing general movement. I complained to the doctor doing my workup about my left foot and she said, "Mrs. Grady, you are one of two hundred people in the deprenyl program and out of those two hundred, you are doing the best.

You will live out your normal life span, but don't expect to be walking during all of that span."

Another gauntlet thrown down. I vowed then that I would walk until the day I died.

Anniversary Party

In *the spring of '88, I received an invitation to a* surprise anniversary party being given by Lainie and Durward Grady's children. It was their twenty-fifth. After I accepted the invitation, I realized that I had a problem. It was a surprise party and usually I stayed with Lainie and Durward when I went to Southern Pines. I couldn't this time or it would have ruined the surprise.

Then I remembered Lainie telling me that Ed Fitchett had moved back to Southern Pines. I got his work and home phone numbers from Lainie's daughter. After calling his home for several days with no answer, I finally reached him at the office.

"Hi Ed, it's Joan Grady. I'm coming to Lainie and Durward's surprise anniversary party. I wonder if you could

make reservations for me at the Sheraton and explain to me how to get there."

He seemed genuinely happy to hear my voice. "Yes, I'd be happy to make reservations for you at the Sheraton. Hell, I'll even pick you up and take you to the party." He laughed.

When Ed came to pick me up, I answered the door. The man standing there was looking at me for the first time as if I were a woman. His manner was different and I was aware of how quietly solicitous he was to me at the party. At evening's end, when he escorted me to my door, we both knew he would stay the night even though no words had been spoken.

We had both changed. I was on Sinemet, and it made a big difference in my life. I had almost convinced myself that I would stay this well and that I wasn't really sick. I felt attractive and like a woman for the first time in a long time.

He told me later that the first two times he had been with me I seemed to have an impenetrable wall around me.

We were together as much that weekend as time would allow without being obvious. New relationships are best

savored in silence. There is no room for well-meaning intruders.

I was going to Florida on business the next week, and we made tentative plans for him to come to Hyperbole the following weekend.

Courtʃhip — E∂

I *spoke to Ed on the phone from Miami to confirm the* following weekend. The week went by swiftly as I looked forward to being home with my special house guest.

He arrived in time for dinner Friday night. I had prepared champagne chicken, one of my favorite dinners.

An intimate fire, embers glowing, reflected the candlelight of the table, adorned with spring wild flowers. *Evita* played softly on the stereo as we sipped champagne, two people responding to each other as if we had a lifetime to cram into a single evening. We took turns speaking, sometimes interrupting with an urgency to communicate with one another. We laughed spontaneously, at times we cried, sharing our innermost thoughts.

Ed, a renaissance man with so many interests, had an incredible zest for life I thought I would never find in another human being.

I had been very apprehensive about my sexual responses to Ed because of the Parkinson's, but in his arms everything seemed normal and I felt an awareness of my body that I had never known. Usually, there is the lover and the beloved, but two people loving each other at the same time is very rare.

This weekend was one of many to come. Ed made the four-and-a-half hour drive almost every other weekend for two years.

When we had been dating four months, early one morning at about three o'clock, Ed had not been able to sleep and finally awakened me.

"I just had to wake you up and tell you that I love you. Are you going to marry me?"

"Yes, I love you too, but marriage is something we have to discuss, preferably in the morning after we have had some rest."

But I didn't rest. My thoughts were of this relentless disease that I was playing host to and how it might impact on our lives together.

The next two years, Ed and I really enjoyed each other, both having a great appreciation of the beautiful. We made future plans for the farm and dreamed our dreams.

Cheryl was the first member of the family to meet Ed,

and she liked him immediately. Heather, my three-year-old granddaughter, was with her.

Cheryl and Andy had had a small wedding, and I had been informed of it the day afterward. She knew that if I had known, I would have wanted to come, but a year later she did share the birth of my granddaughter with me, and I stayed with them a week.

Heather and Ed became buddies. When he was there for the weekend she followed him everywhere. Ed was very patient and loving with her.

When they went home she shared with her father, "You know Grammy has a friend named Ed, and I love Ed and he loves me."

In that two-year period Bob, my son, and Claudia, my daughter, and their families all visited Hyperbole, and everyone approved of Ed.

Not that I needed their approval, but it made it nicer. From the very beginning Ed and I didn't need other people to have a good time. He loved the animals as much as I did and helped me with my chores.

We rode occasionally. Ed rode Eli and I rode Bay because Bay could be skittish at times, and I didn't know if Ed could handle him.

In the course of those two years, I met Ed's mother and

father, his daughter, Aubrey, her husband, Dave, and his son, Carter. I think that they all liked me, however, I did not share with any of them the fact that I was ill.

Whenever we discussed my illness, Ed didn't seem to understand that the disease would get worse and that although I had been extremely lucky so far, my luck wouldn't hold out forever, and eventually this disease would conquer me.

I gave him books to read about Parkinson's disease, but he never read them and he never wavered in his commitment to me—he wanted me to be his wife and share his life.

Business Problems

Marketing our Miami property became more stressful. I couldn't convince my brother that we needed to lower the price. The conflict continued between us until we were barely speaking. When the current tenant, a large video franchise, expressed an interest in purchasing the property, I knew that we had to negotiate the best price we could from them and sell it.

In 1986, with Reaganomics in effect, credit interest was no longer a write-off, and this sent the real estate market into a tailspin. In 1988 it was still going down. Large savings and loans which had heavily invested in real estate went under, and the market continued to spiral downward. The taxes on our property were $50,000 a year, and the interest on our line of credit was equal to that.

I had made some substantial money on the sales of my

French clients' properties, but thinking the property would sell the first year, I had overextended myself.

In 1989 this conflict between my brother and me came to a head, and he hired an attorney to represent him. This development prolonged the sale a year longer. When I was at the point of complete mental and physical exhaustion, my brother finally agreed to the sale at a much lower price. Time was a precious commodity to me, and my brother's stubbornness had robbed me of a lot of it.

After one of my exhausting trips to Florida, Ed met me at the airport and took me to lunch at the Red Lobster in Asheville. We had been postponing setting a wedding date until Miami was settled.

After the waitress left with our order, Ed took a sip of his beer. "I know we planned to wait until the property was settled, but I've picked out a ring that I want your approval on. It's a one-carat stone. After lunch I thought we would go and have it fitted. We need to get on with our lives together. Your brother has taken too much of your time and energy already."

"How did I ever get lucky enough to find you," I said, tears mixing with my laughter.

A l a ɗ k a

In *the fall of 1989, Lainie and Durward Grady invited* us to go on an Alaskan fishing trip with them. They were avid fishermen, and this would be their second trip to the Fishing Unlimited Lodge, though our first.

Durward was full of excitement as he told us of the trip, and I was full of trepidation. The itinerary he had just explained would be enough to overwhelm a healthy person, and after we said yes, I began to think of all the things I might have trouble doing.

By 1988, I had reached the peak of my fitness on the farm. I could offload five hundred pounds of fifty pound bags of horse feed into the barn, empty a truckload of shavings into the barn shed, muck out all the stalls, and feed and groom all the horses. I tried to ride at least once a week, when time permitted. I was so masterful with the weed whacker that I could take it apart and put it back

together again. Most of the time I mowed my own lawn around the house. It was nothing for me to walk the perimeter of the farm at least once a day and sometimes more when looking for a lost creature of some sort. However, I could do all of these things at my own pace—Fishing Unlimited would be at the lodge's pace. I became apprehensive that I would be a burden to the Gradys and Ed.

I thought about it a lot and decided to just do the best I could do and enjoy the experience.

I planned my clothes, packing with care, following Lainie's suggestion to bring lots of things to layer and rag-wool socks. We also brought waders.

We flew out of Raleigh/Durham airport to O'Hare in Chicago. Then we took Delta to Anchorage and spent the night. The next morning we flew through glacier-capped mountains to Lake Clark and the Fishing Unlimited Lodge. Each couple had their own cabin, and we would spend the next five days fishing for various kinds of salmon.

Breakfast was served the next morning in the main lodge at seven, after a six-thirty wakeup call in our cabin with coffee and juice.

After breakfast we boarded a single-engine float-plane

and fished all day. The lodge packed a lunch for us. Dinner would be served in the main lodge at seven.

After the first half day of fishing, I realized that Ed would be very little help in teaching me the rules of fishing. He was too excited about fishing himself. So I explained to Randy, the pilot and guide, that I would need some extra help. But he already knew, as a seasoned guide, that mates made poor teachers.

When we fished with our waders on, the stream bottoms were extremely slippery. Initially I was not aware of the danger of wading into the water with hip boots on. If you lost your footing and fell into a rapidly moving stream, your boots would fill quickly with water and you could go under and drown. Randy would walk me out in the stream to a good spot, and I would stand there and fish, unaware of any risk. When it was time for my medicine, which I kept in a pouch in the front of my jacket, Randy would wade out to me with a coke, and I would take my medicine midstream.

Randy taught me to fly-fish. I cast my rod right-handed and became fairly proficient. When we went to Kodiak Island, I caught the biggest fish of the day.

One morning Randy set the plane down in a wide river mouth. We began catching salmon. Most of the time we

released them as we were mainly fishing for sport. Today Randy was going to grill us some salmon for lunch, but we had an unexpected guest who must have smelled the aroma of salmon cooking—a young brown bear. When he first appeared over the ridge about a hundred yards from us, I ran up the ridge waving my floppy blue hat at him, and he ran away from me, but the scent of salmon finally prevailed. We have pictures of him right at the tail of the plane as we are taxiing for takeoff.

I didn't fish everyday. Sometimes I would spend the day resting and reading, but I felt that I hadn't been a burden to anyone except Randy, and he didn't seem to mind. He gave me a big hug the day we left and told me he was proud of me.

..

Parkinson's Revisited

One morning early, Leonard and I were walking back from the barn and he asked, "Are you still taking your medicine?"

A warning bell went off—I had gotten worse and Leonard was the only person brave enough to tell me. My left leg was continuing to decline. Once I had had good days and bad days with this leg. Now I was having bad days and very bad days. The nerve in the femur muscle that controls the lifting of the leg was misfiring and my gait became awkward and painful. However, when I walked backward or ran forward, I had no signs of a limp.

In New York, Dr. Yahr told me that the Sinemet was causing it. We started staggering the medication; a half-pill at first dose and a half-pill two hours later. This worked for a while, but I found at times of stress or if there was a change from my normal routine I needed

more Sinemet. While the drug would meet the immediate crisis, I eventually paid for it. After a few days the muscle controlling my leg would get worse. I would have to back off the Sinemet and rest for a few days—clearly a condition I wasn't willing to live with.

At this time, I was still on three Sinemet a day and occasionally one more or half of one if the day was particularly stressful. I continued to take the Symmetrel and the deprynel.

There is a classification of drugs known as dopamine receptor agonists, and bromocriptine is one in this category. Two of the bromocriptines were Parlodel and Permax, one of which interacting with the Simemet would, I hoped, lessen my limp. They had a lot of bad side effects until your body adapted to them, and Dr. Yahr was not in favor of my going on either one of them. The deprenyl program was coming to an end. To my surprise, deprenyl cost $2 a pill, and I took sixty of them a month. During the program they had been dispensed to us without charge.

I traveled to Florida on business frequently and decided to see if it might not be time to change doctors. I always knew that if I got into serious trouble I could go back to Dr. Yahr. I left him on very friendly terms.

...

Dr. William Weiner

I *needed to find a doctor in Miami. I knew that the main* headquarters for the National Parkinson's Foundation was located in Miami. One day, just by chance, I was speaking to a realtor friend of mine whose daughter was a nurse. I knew Emily's daughter, Carol, and when Emily mentioned that she was working as a research assistant with a neurologist who was affiliated with the University of Miami, she got my attention. I got Carol's phone number from Emily and called her.

Carol told me that the doctor she was working with, William Weiner, was affiliated with the University of Miami Medical School and was head of the Department of Movement Disorders. She suggested that I make an appointment to see him.

I have always thought there is a direct correlation between greatness and humility. Dr. Weiner had a quiet,

unassuming attitude, with an astute introspection that only comes when you are terribly bright and very secure. In his early forties, he stared at me through horn-rimmed glasses as I proceeded to apprise him of my latest complaints.

He gave me the usual examination, with one exception. He asked me to lie down and to roll from side to side. He said I was a "two" on the Hoehn and Yahr Scale. Dr. Weiner agreed that I should go on Permax to mediate the Sinemet. He started me on a very low dose and increased it slowly until I was on 0.50 milligrams, three times a day.

The Hoehn and Yahr scale, named after Dr. Yahr, is a famous diagnostic measurement of the progression of Parkinson's disease. It is a scale of one to five, five being the final stage. I asked what a "two" was, and he said that the disease hadn't moved into my right side yet.

I brought up the subject of transplant surgery to Dr. Weiner, and he felt as Dr. Yahr did that it was still too experimental for him to recommend.

The National Parkinson's Foundation has very active support groups and publishes a Parkinson's newsletter several times a year. For some people a support group can be very constructive and beneficial, so that they know that

they are not alone, but I am a loner and it has not been for me.

As a matter of fact when the Parkinson's newsletter comes if I am not very selective in what I read, it depresses me.

..

Miss Julia

To *this day, whenever I see a collie, my eyes glisten.*
Border collies are considered the brightest breed of dogs,
and Miss Julia was no exception. On the farm she be-
came my alter ego, guardian, and protector. When we
walked the mountain roads she would bound ahead of
me, tail waving like d'Artagnan's plume, to see what mis-
chief she could get into, but if we were walking off the
roads into the woods, she never strayed more than five
feet away.

She knew my routine with the horses, and if anyone
deviated from that routine they were challenged or
nipped depending on the severity of the offense. When it
was time to go to the barn to feed, Julie would harass me
until I finally acquiesced to her demands.

Miss Julia spoke to me when she wanted something.
When she had done something naughty and wished to

appear innocent, her facial expression was so comical that I called it her "Jack Benny" look.

When I had visitors on the farm who brought their own dogs, Julie would greet them like the perfect hostess and then proceed to do them in. She would start to chase the chickens or the geese, and when the "guest dog" started after her, she would quickly stop, run up the bank, and watch the other dog chasing them. The other dog would be punished and Miss Julia would look angelic. If the dog-visitor was a city dog, she would race the horses around, encouraging the city dog to participate and would dart out of the way just in time for the city dog to get kicked.

Julie went everywhere with me. At the bank, the drive-in teller kept dog biscuits for her, and once she was securely ensconced in the car or truck, dynamite couldn't blast her out of it. If I left the farm without her, she would follow me, so I had to pen her up.

On my occasional visits to Southern Pines, I took Julie with me. We stayed at Ed's house in the middle of the city, across from an elementary school. She had never encountered squirrels before. They taunted her unmercifully.

Julie was a country dog. I wondered how she would

make the transition to the city—I wondered about us both.

On 14 December 1990 at about eleven o'clock in the morning Julie darted across the street after a squirrel. The truck didn't see her until the last minute. Losing a friend after eight years of companionship on the day before our wedding was a cruel twist of fate.

Difficult Decisions

W*e had set our wedding date for 15 December 1990,*
but in the six-month period before our marriage, we had
some difficult decisions to make. By this time Ed had been
back in Southern Pines for five years, he was a partner in
his firm, and the firm was doing extremely well. I didn't
think it would be fair for him to give all of this up so that
we could live on the farm. We decided to sell his house in
Southern Pines and buy some local acreage and transfer
the animals to Southern Pines, but we weren't at all sure
about giving up the farm.

However, fate stepped in and made our decision for us.

Goliath died on 17 December 1989 of a kidney infec-
tion, after lots of medicating and caring. Leonard buried
him in the backyard under the willow tree.

The next casualty was Ashley. I came home from a

Miami trip and found him dying under the deck. It was as if he had waited for me, and he died in my arms—such an irony, because in life I could barely touch him.

Scarlet paced around him making little squeaking sounds, trying to comfort him. He didn't have a mark on him, so I decided that he just died of natural causes.

When I purchased Sunshine in the spring of '87, I had a sonogram done to make sure that the foal was all right. I had another one done three months later and was told everything was fine. But everything was not fine. Sunshine was pregnant with twins. If the vet had picked up the two heart beats, we could have destroyed one of the foals and she would have carried to full term, but instead she aborted both foals at six months.

"I am very sorry about this," the vet said, "but you can always breed her again."

We made the decision to find good homes for Bay and Firecrack. Eli, twenty-eight and failing, we would put to sleep. We would keep Sunshine and breed her again. It was decided that Hershel would board her until she was bred, and then we would move her to Southern Pines.

Sunshine had one problem after another. After Hershel had had her for about six months, she was kicked one day

in the pasture. The vet said that her stifle was damaged. The stifle, above the hock, serves as the hind knee of a horse. After another six months of vet bills, the vet said that Sunshine's stifle couldn't be repaired, and we had to put her down.

Wedding Plans

W*e decided we would like to be married in the Episco-*pal Church in Southern Pines and have a small gathering for lunch after the service.

Finding just the right dress for a fourth marriage was not easy. After fourteen years of being single, getting married was a big step, so my dress became the symbol, in my mind, of the marriage itself. I looked at all of the special places in Asheville, but nothing was just right. I knew when I saw the right dress, I would know it.

I had several problems. I became overheated very easily and would perspire profusely. I had to have a dress that covered but was not too heavy a material. I called the shop in Miami where I bought most of my clothes and asked Ollie to find me something.

On my next trip to Miami, Ollie told me she had found just the right dress. I went to the shop and tried it on, but

it wasn't right. If Ollie couldn't find the right dress, maybe the right dress existed only in my mind. I told her I wanted a day to think about it.

The only other shop that I hadn't considered was Lillie Rubin's. As I entered the shop, a matronly Spanish lady approached me, "May I help you?"

"Well I'm not sure that I'm not beyond help, but you can try. I am looking for something for a morning wedding."

"Are you the mother of the bride?"

"No, I'm the bride."

She stared at me for a moment as I started to explain this dress, that I wasn't sure by this time that the right dress wasn't a figment of my imagination.

She left the room and after a few minutes came back with "The Dress." It was off-white and three pieces, consisting of a chiffon waltz-length full skirt, a silk camisole top encrusted with pearls and bugle beads, and a lightweight wool jacket, trimmed to match the camisole top. It fit perfectly. I finally felt secure about this marriage.

Lainie and Durward were our matron of honor and best man. We invited Ed's parents, Ed's children; my children and grandchildren; Ed's partner and his fiancee; and a few close friends.

Bobby, my son, was divorced and had custody of his son George, twelve. Claudia was still in England and did not attend, but was there in spirit. Cheryl and Andy attended, accompanied by my granddaughter Heather, who was four now, and our flower girl.

It was an overcast day, but I was very sunny inside. When we arrived at the church, Sam, the rector, had us sign the necessary papers along with Durward and Lainie. Ed looked so handsome in his dark gray pinstripe suit. Lainie had on a deep blue silk suit that enhanced her red hair, and Durward looked distinguished in his dark navy suit. I was afraid that I would start crying; I always cry when I'm happy.

The ceremony was at eleven. In the middle of the ceremony at the altar the rector asked us to kneel and pray. When I got down on my knees, my left leg started to shake uncontrollably. Out of the corner of my eye, I could see Heather moving toward my leg so I quickly adjusted my position. Miraculously my leg stopped shaking and Heather stopped moving. Timing is everything in life!

Our luncheon at the Country Club of North Carolina, resplendent with champagne, wedding cake, and photographer, was at noon. I was very relaxed and enjoying myself as much as my guests. Carter, Ed's son, made a

thought-provoking toast, "Here's to Dad and Joan—this is my Dad's third marriage and Joan's fourth. Let's hope that seven is a lucky number."

After lunch we cut the cake. Ed fed me a piece and I fed him. Heather thought that this was a fun game and insisted on feeding me a piece of cake too.

But the nicest gift of all was from my Parkinson's disease: I had one of my very good days.

We went on our honeymoon to Washington and Williamsburg a week later.

Saying Good-bye

I *made the move to Southern Pines in stages. At first just* clothes and personal items. It was just after the wedding and I was at the farm without Ed.

The only animals left were my barn cats, Scarlet, and Alice B. Toklas, a white goose that I purchased to keep Scarlet from being so lonely after Ashley died.

I heard Alice honking that morning outside my bedroom window, and I couldn't find Scarlet. By this time I knew that both Scarlet and Ashley were males, because they never laid any eggs.

I looked around the house and the barn and no Scarlet.

I saw the mailman and went down to get the mail.

I found Scarlet at the side of the road, struggling to get up. Something had obviously attacked him, probably a fox.

Picking him up was no easy task because he must have

weighed close to forty pounds. I carried him carefully to the house, got an old blanket, and covered him with it as he lay on the deck. I sat next to him crying quietly— would the deaths ever end?

I lived on this remote farm by myself for eight years and was never kicked, never fell, and was never bitten, and yet the attrition rate of my animals had wounded my soul in a way I would never quite recover from.

Leonard came down, and we buried Scarlet under the willow tree in the backyard next to Goliath.

Leonard sat on the deck steps. We had some things to discuss. He had been such an important part of my life for a long time. I knew that although we would see each other in the next months and years, life as we had known it was over.

I sat beside him on the deck enjoying the warmth of the January sun, staring at the empty barn surrounded by manicured pastures and stark wooden fencing framed by the naked trees of winter. We were silent.

Finally he spoke. "I'm going to miss you. I've gotten used to you."

My Nostrils Don't Flare

Gone is the sweet stench
of manure.

Brittle leaves lie restless
on the earthen floor.
A swallow swoops and scolds
as I near her nest.

Massive chestnut doors
no longer impede,
hand-forged hinges
rust.

Mangers are filled
with empty cobwebs.
Sawdust stalls,
too clean,
lie dormant.

Sounds are absent,
equine voices gallop
in another place.

I stand quiet
in the aisle
remembering,
My nostrils don't flare.

..

Returning to Civilization

Living *in the country and being at ease with good friends* had become a comfortable lifestyle. When I moved to Southern Pines, I was out of my comfort zone and on display. Lainie and Durward were dedicated friends, but they led a very fast-paced life—one that Ed and I couldn't keep up with physically or financially. For a time we tried, but we were headed on a bankrupt course that we had to modify.

Ed was very protective and solicitous, and I found myself letting him do more and more for me and settling into a pattern that I had always tried to avoid—letting others do for me.

We sold Ed's house and rented a townhouse, which we subsequently purchased and settled in. After much soul searching we decided to put the farm on the market, be-

cause the long-distance upkeep without our living there was getting prohibitive.

Ed designed several houses for us, but they all were more house than we really needed. I knew in my heart that I was approaching the time when I wouldn't want to be responsible for a large home.

..

Moving — Barbara Helps

Without Barbara and Frank, I wouldn't have made it on the farm. Next to Leonard, they were my closest friends. Their friendship was given freely and with great love.

Barbara Caracci, Frank's wife, will always be one of my best friends and is one of the funniest women I have ever met. She played the straight woman in our comedy routine and like most funny people, didn't even know she was funny.

Frank could fix anything, and Barbara could imagine everything was breaking, so together they were priceless.

When I went to New York for the deprenyl program, I told Barbara that it was supposed to arrest the disease. She said, "Does this mean that we aren't ever going to get to park in the 'crippled parking space'?"

One day Barbara and I picked up four chairs that I had

ordered at Sears. I had the truck, and when the box boy started to load them on the truck, I asked, "You're putting these boxes in here securely? They won't fall out?"

"No ma'am, they're in there tight as a drum."

We had pulled onto a four-lane highway and were just going over the crest of the first hill when one box blew off, followed shortly thereafter by the other two. I saw this in my rearview mirror and pulled over to the side of the road. Barbara said, "What are we pulling over for?"

"Look at the road, silly, my chairs just blew away."

Brakes were screeching and cars were maneuvering wildly to avoid hitting the three cardboard boxes. A very nice man in a truck pulled over to the side of the road and asked us if we needed help.

"You need to back your truck up about fifty feet," he said.

"I don't back," I said.

"Would you like me to do it for you?"

"I would really appreciate it, thank you."

Not only did he back up the truck, but he retrieved the boxes, and I thanked him profusely.

"Are you going back to Sears and demand new chairs?" Barbara asked.

"No, the boxes weren't broken, and I'm grateful that no one was hurt."

When the farm was finally sold in March of '93, Barbara and Frank helped me pack. It took three very funny days. Frank, who had helped to build the house, came over on the first day. He started telling us that we weren't packing correctly, so we said he would just have to stay and supervise. He was with us most of the time after that and didn't seem to mind having been conned into helping.

I had a large crystal vase on the floor in the dining room. It had very long-stemmed pussy willows in it. I went into the kitchen to get a garbage bag to pack them separately, because it is very difficult to find long-stemmed pussy willows. Frank was standing behind Barbara when I opened the plastic bag and asked her to put the willows inside. She picked them up and very abruptly snapped them in half, stuffing both halves in the bag. Frank and I looked at each other, and I started laughing.

"What's so funny? Let me in on the joke," Barbara said seriously.

"I got a special bag to wrap them in because I wanted them with the stems on."

Frank was hysterical, "You'll just have to put them in a shorter vase."

"I still don't see what's so funny," she grimaced, and Frank and I laughed harder.

It became our motto during the move. Watch out for Barbara or she will snap you in half.

I spent the night with Barbara and Frank the day before the movers came. We got up early the next morning and drove down to my place. There were three movers, and it didn't take them long to bare my little house. Barbara and I were standing in the kitchen when she whispered to me.

"You don't think the movers think that we're lesbians, do you?"

"Why?"

"Why! Because we're two women alone and they aren't moving out anything masculine—it's all feminine stuff. Don't you think they'll think that's strange?"

"The thought never occurred to me because actually, you're not my type."

After I stopped smiling at her she marched into the living room and in a very loud voice said, "My husband should be down here any minute if there is anything you need extra help with."

After that announcement she seemed satisfied.

..

Echoes

They took the furniture
this morning.
Three men,
one, very tall, named Marty,
counted and numbered the boxes.
"It's just stuff," I say to myself,
"You can't box up dreams
Or nightmares."

Intimate rooms stand empty.
Walls stare at me.
Do they remember
sharing my laughter,
absorbing my tears.

On the vacant deck
I shout at the mountains

"Hy-per-bole"
Listening for last echoes.

Marty says, "We're all done
Just sign here."
With a stroke of the pen
a life disappears.

..

Southern Pines

My *first year in Southern Pines was a busy one.*

I found Full Cry Farm, owned by Mike and Irene Russell, who were friends of Ed's, and rode at least once a week. Lainie started riding with me, and it was even more fun. I felt comfortable in the saddle and my legs were very strong, but my neck had lost some of its agility. I was always a little apprehensive crossing the highway because my neck was limited when I tried to turn it to the left. An interesting fact though is that I never trembled on horseback.

My upper body was stiffer than it should have been for maximum riding agility. One beautiful autumn day, the air crisp as celery, Mike, Lainie, and I started to have a leisurely ride through the woods. We were riding along and didn't know that there were horses in the adjacent fenced field. As they came galloping up to greet us, our

horses heard them first. My horse jumped five feet into the air and sideways. I stayed on and didn't even lose my stirrups, but it frightened me. Parkinson's disease creates fear, and you have to fight it all the time. I rode several times after this, but it was never the same, so I knew it was time to quit.

I also had my first attack of vertigo during this same time frame. Balance is usually one of the first things to deteriorate in Parkinson's patients, but mine had always been good. One of the difficult emotional problems I had with this disease was that when I got sick, I had to determine whether the Parkinson's had gotten worse or if I just had a normal affliction that, given the proper attention, would heal.

I enrolled in an adult education writing course at Sandhills College. Here I met some of the most interesting and talented men and women I have ever known, and they were to become my good friends.

The teacher, Peg Campbell, was absent for the first class, and students milled about cautiously exchanging pleasantries. Angelee and Ethel, who had taken this course before, seemed comfortable. Sally, who would become my closest friend, was aloof and distant.

I arrived a few minutes late for the second class, and

when I was introduced to Peg, I froze. She seemed fragile and acerbic—a very disarming combination for a writing teacher. She probably had forgotten more about writing than I will ever know, but the manner in which she disseminated this knowledge struck fear in the hearts of many of her students. I was no exception.

I found myself trying very hard to please her, and as a consequence, I learned.

It had been time to change gears, but I missed the animals and the farm a great deal. Writing about the farm seemed to help fill this void—particularly my poetry.

I found that I had to take more Sinemet when I went to class. In spite of my best efforts, my hand trembled when I had to read in front of the group.

I knew I had to concentrate more on my intellectual prowess to prepare for the day when I might not be so physically active, when my "flying days" were over.

Ed got me hooked on crossword puzzles, which is an addictive pastime. It would also be a good barometer in my constant fear of dementia.

In '94 I met Nancy, who was a friend of Ethel's, and we

started to play duplicate bridge together. It has been a very successful partnership, very challenging because I have a very unpredictable left hand, but most of the time sheer willpower and a patient partner gets me through the bad days.

..

Parkinson's Hands

She looks down at
hands that tremble,
and remembers when
they learned to cook
and sew and write.
Hands that tied shoe laces
and buttoned blouses.

Animated hands,
that moved rapidly with grace
as she spoke,
displaying long fingers
with perfectly
polished nails.

Agile hands,
that gripped a tennis racket

and placed tinsel on the tree,
strand by strand.
Hands that held a child,
brushed away tears,
caressed a lover's face.

Hands
that no longer
listen to her
commands.

Ireland

In the fall of '93, we made a trip to Ireland. I was apprehensive about spacing my medications with the eight hour time difference, because you doze, you really don't sleep on an airplane going to Europe. I decided to take my medication every three hours on the flight over and gradually wean myself when we got there.

This was a trip that I had always wanted to make. We were gone for seventeen days. I knew there were places in Ireland I had been to before, even though this was my first time there—in this life.

We landed at Shannon Airport and picked up our rental car. Ed drove south trying to remember to stay on the left side of the road. He was exhausted. It took us an hour and a half to make the thirty-minute drive to Adare. I had failed as the co-pilot. After spending the night at

Adare, the next day we drove to Moran on Weir, south of Galway, to meet our friends, Mary Lynne and Carl, who were living in Ireland.

We spent that night in Galway. An attractive young couple owned the bed and breakfast where we stayed. They collected antiques. When we came back from dinner, they invited us to sit by the fire and have a toddy with them. It was a pleasant evening as we talked about collecting antiques.

Early the next morning, we set off for Connemara and had lunch at a quaint restaurant in Round Stone, which is on the sea. The people at the table next to us were having stuffed lobster. It looked so good I decided to order it too. Ed joined me. On the way back to Galway, we stopped at a hotel to use their facilities. I went to the ladies room, and my stomach started rumbling. I didn't think much about it because I have almost a cast-iron stomach. At about four in the morning I woke up and felt very strange. I went to the bathroom, and I knew my stomach was very angry about something—I was really sick. I didn't wake Ed, but when he woke up about seven, I was feverish and couldn't seem to stop shaking. I took more medicine hoping to get my Parkinson's under con-

trol, but I continued to shake. "Now you have done it, Joan, thousands of miles from your nearest doctor, you have gotten ill, so you will just have to sort this out yourself."

"Ed, I think I will just stay home and rest today, you go on with Mary Lynne and Carl and have a good day. I'll be just fine."

I was relieved when they left, because I didn't want them to know just how sick I was. It would have ruined their day.

Carol, the bed and breakfast owner, brought me some hot tea about nine o'clock. She took one look at me and knew I was desperately ill. She wanted to call the doctor. I tried to act well saying, "Carol, I just look like I'm dying, I'm really not."

I don't think I convinced her, because she came up every hour or so and was very concerned.

It was about one o'clock before I could even consider trying to swallow some tea. This is one of the few times in my life that I was really afraid—not knowing what is wrong causes more anxiety than the illness.

At about three o'clock, I had tentatively diagnosed myself as having food poisoning, exacerbated by the Parkinson's. Having put a name to my malady helped

considerably. I got up around four, took a shower, and drank some more tea.

Ed and company didn't get back until after six. I told Ed that I had been sick, but I was on the mend. I didn't feel strong enough to go out to dinner, so they brought food back for me.

The next morning, we struck out on our own and got a real flavor of the Irish countryside. The Glebe House near Collooney was a country manor house that a young couple were restoring. We had a fireplace in our bedroom and a private bath. Dinner was served by candlelight, the dining room fireplace sending the fragrance of sap-filled logs into the intimate room. Edith Piaf warbled her French love songs on the stereo, permeating the full-bodied red wine as we drank in the moment. Glebe House was a place revisited by me. I felt I had been there before in some life, smelled the sweet aroma of burning peat, watched the geese preening themselves on the front lawn, and heard the rooster crowing in the large oak. I didn't want to leave.

We drove through Ireland exploring on our own places not on the tourist agenda; it was really a romantic adventure. However, it meant packing and unpacking almost every day, something that I didn't do very well and

Ed had no patience for at all. I didn't realize just how much ground I had lost physically until I tried to keep up a rigorous "tourist schedule."

I knew if we ever took another trip we would have to modify the baggage situation. However, I will always cherish our Irish journey and my déjà vu with Glebe House.

Lo𝒹ing Groun𝒹

In the years between '91 and '94 I gradually lost ground to my disease. Ed was so good at picking up my pieces when I came unglued that it was a long time before I realized just how much ground I'd lost.

Gradually my voice became fainter, particularly under stress. The disease was so insidious that at times when I concentrated, my voice would be almost normal.

I began to have good days and bad days, good weeks and bad weeks. On a good morning, before taking my medicine, I would feel well. I could walk without a limp, my voice clear as a bell, and my dexterity levels were almost normal. However, if I waited too long to take my medicine, I would deteriorate to the point that I couldn't even cut my pancakes with a knife.

Buttons had always been difficult, but I vowed never to

give in to velcro. I finally purchased some slacks with elastic around the waist—a real defeat for me.

Ed did most of the driving, and it was some time before I realized that I could only drive for thirty minutes at a stretch before becoming exhausted. Driving at night became a problem, and most of the time Ed drove. The irony was that happiness and relying on Ed were destroying my health. I was in danger of losing my independence.

There was a lot in the news about Parkinson's in '95. I read a book that I hoped would change my life, *The Case of the Frozen Addicts*, by Dr. J. William Langston and Jon Palfreman. It was a study of the addicts who got the bad batch of heroin in California in 1982. Dr. Langston tells a compelling tale of the research that focused on these addicts because of their Parkinsonlike symptoms.

A chemist synthesized a drug that was supposed to emulate heroin—MPTP. This is the drug that caused the Parkinson's symptoms in California. But the information that intrigued me the most was that Demerol was an analog of MPTP. This meant that the drugs had the same ingredients, just different amounts.

In 1979, I had had some minor surgery and was given Demerol. Six months after the surgery my Parkinson's symptoms began. This really intrigued me. I wondered

whether or not there was any correlation between the Demerol and my symptoms. If the Demerol had triggered my Parkinson's, it could mean that transplant surgery could be very effective for me. I hadn't had enough Demerol to do any permanent damage, so chances are I could possibly get well. I became more determined than ever to seek out information on fetal transplant surgery.

By 1986, there had been a lot of research on the transplanting of fetal tissue from aborted fetuses into the brain and a great deal of controversy about the moral implications.

In '88, President Reagan banned all federal funds for fetal research. This ban was continued through the Bush administration. In his first week in office, President Clinton rescinded the ban.

Dr. Langston's book talked about the politics of medicine. For example, the National Institute of Health, the world center of medical research in Washington, is a very political institution.

Eighty percent of NIH's $10 billion budget helps fund basic and clinical research at universities around the United States, with the power to withhold information and funds if it suits them. In my opinion, they seem to sacrifice patients for politics.

Transplant Investigation

In *the spring of 1995, I had several episodes of* "freezing" and it really frightened me. I would ask my body to perform a simple task like rolling over in bed, and if I had had a particularly stressful day, my body would not respond. I would thrash around in bed, not wanting to bother Ed, but he would sense my distress and come to my rescue. We would laugh about it in the morning, but we were both worried.

I read an article in the paper that a Dr. Olenow, who had conducted some successful transplant surgeries at the University of South Florida in Tampa, was now affiliated with Mt. Sinai in New York.

I had an opportunity to fly to New York on a "buddy" pass with my friend Wilma, who was a stewardess.

After discussing this with Ed, we decided I would make an appointment with Dr. Yahr. My daughter Claudia, who

had moved back to the United States and was living in New York, agreed to meet me at Dr. Yahr's. I would visit with her and her growing family for a few days. Claudia now had three children; Andrew, eleven; Christopher, nine; and Emily, six.

"Dr. Yahr, I am calling to see how you feel about fetal transplants at this time?"

"Well, we're starting a new program. Why don't you let me have a look at you, if you are going to be in New York?"

Wilma and I arrived at LaGuardia at about three the afternoon before my morning appointment. We checked into a downtown hotel, had dinner, and went to the theater.

The next morning, after Dr. Yahr's assistant, a young woman in her twenties, had done a cursory examination, I saw Dr. Yahr.

"You look good, but I don't like all of this extra movement I'm seeing. Stand up and let me check your balance. I know my assistant checked it, but I like to do some of these things myself". He stood beside me. "Your balance is excellent."

"Tell me about your program."

"Well, I'm not sure that it's for you. You're not sick enough, and there will be placebo patients."

"Dr. Yahr, you told me that the Sinemet would last between five and eight years. I went on Sinemet in 1986, so I'm on borrowed time right now. I have been noticing this past year that my facial muscles do not always respond to me when I wish to smile, but I can still blink my eyes, thank goodness. Sometimes I look in the mirror and I am beginning to see a mask."

"Not all people respond to Sinemet the same way, Mrs. Fitchett."

"Please, put me on the list for your program. Are there any other institutions doing this transplant surgery that you know about?"

"Yale University is, and they will not have placebos in their program, but they are having trouble getting funds."

Dr. Yahr's secretary gave me the name of the person to contact at Yale.

I called Candace Waltz at Yale, and we had a long chat. We liked each other. She said that their program had been postponed for several months and to call her in September. I called back in the fall, and they sent me the necessary papers to fill out. Then a short time later, I received notice that the project had gotten bogged down because of lack of funds. I was told to call Yale in the spring of '96, but at that time they still didn't have their funding.

However, Mt. Sinai was ready to go forward, and they sent me the necessary papers to fill out in April of '96.

They would be accepting eighteen patients—twelve would receive the transplant surgery and six the sham surgery. At the end of the two-year program, the six patients would receive the real surgery. There was a release form that had to be signed, informing the patients that they would be put on an anti-immune drug called cyclosporine. It was a steroid with some nasty side effects, including overriding the body's immune system so it wouldn't reject the new tissue. This might have been worth the risk if I were receiving the real transplant, but not the placebo. I asked Dr. Yahr if the placebo patients would get placebo cyclosporine and he said no.

Then I read an article in the Parkinson's Report, a newsletter published by the National Parkinson Foundation, that the University of Colorado, in Denver, had some disastrous results with anti-immune drugs in their transplant program. They found that it killed the new tissue.

Putting all of this together, I realized that I was back at square one, but it was too big a step not to get all of the facts.

..

Flying

Life has no color now.
I spend my days
looking for lost things,
trying to remember.

Like a wounded bird,
flapping its wings,
earth bound.

At times,
I can still feel the
wind on my wings,
looking down at lost horizons,
soaring to taste the rain.

Parkinson's Pursued

W hen I had moved to Southern Pines, I had felt that
it was time to have a local neurologist in conjunction
with Dr. Weiner. Peter Lars Jacobson was recommended.
Of all of my doctors, he was my favorite. He had a mar-
velous sense of humor, and almost immediately we be-
came kindred spirits. He was a graduate of the Mayo
Clinic School of Medicine—it doesn't get much better.
He was the only one of my doctors who encouraged me
when I finally made the decision to have the transplant
surgery.

I made an appointment with Dr. Jacobson, and we dis-
cussed my options. He suggested that I contact the Mayo
Clinic to see if they were doing any Parkinson's research.
He also suggested that I contact the University of Col-
orado. I knew they were doing transplants because of that
article in the Parkinson's Report.

I called the Mayo Clinic first and was told that all inquiries had to be in writing. They answered my letter promptly and said that they were not doing any Parkinson's research, but that the University of Colorado was doing the transplant surgery.

I was pleased that Mayo recommended Colorado. I had also been in touch with the University. They told me over the phone that they were accepting private patients. I was excited. For the first time in a long time I dared to let myself believe that I could be well and jumping hedges when I was eighty.

The University of Colorado had stringent requirements even for private patients. Five hundred dollars bought me a videotape of instructions. I had to videotape myself twice a day for two weeks, and one day each week I had to tape myself fifteen times. On the tape, I had to say the first line of the pledge of allegiance, the date and time, walk about twelve feet to a chair, sit down, turn first my left hand and then my right over and under on my thigh six times with each hand, fold my arms and stand up, and with arms down, walk back toward the camera. I taped myself before medication in the morning and then one hour after medication.

In addition to the videotaping, I had to keep a diary of the times I took medicine, when I ate, when I slept, whether or not the medicine was working, and if I was experiencing any dyskinesia—muscles spasms due to the side effects of the medications.

I also had to write a two-page dissertation on the history of my disease, get releases signed, and have my doctor's records sent to the University.

It could take as long as three months to evaluate the information. If I was accepted as a candidate for surgery, I would then have to go to Denver for five days of physical and mental examination. If I passed the examinations I would be scheduled for surgery.

I sent in all of the requirements for the first phase and waited impatiently to be accepted.

My health continued to deteriorate. One evening while dining out at an exclusive new restaurant, I needed to go to the ladies room. I gave my body the signal to stand, and it was as if my body were deaf. It didn't respond. I tried several more times without success.

Ed leaned over the table, sensing something was wrong. "I'm afraid I can't move," I said, trying not to sound desperate. "I need to go to the ladies room, but you're going to have to help me."

Ed stood up and gently pulled me to my feet, smiling as if it were something he did every day.

"You're also going to have to lurk around the ladies room," I said, laughing at my dilemma. When I had succeeded, with great concentration, in getting my slacks down and then up again, there was no way I could button them. I gathered myself together, took a deep breath and exited the ladies room, where I found Ed, who with all of the stealth of a secret agent, buttoned my slacks.

Later that night lying in bed, I started to laugh, thinking—nobody can fly with their pants down—knowing that my surgery was just a few months away.

...

Waiting

The days before my final acceptance by Colorado were long and restless. I had no patience. I thought about what might happen if things didn't go well, about dying or being incapacitated by a stroke, or blinded. In ten percent of all surgeries something goes wrong, but rather than wait around and watch my body slowly deteriorate, I had opted for surgery. Now that I had my mind made up, I was ready for it to be over with.

Ed didn't say much, but when he did it was, "How will I ever live without you if something goes wrong?"

At last I heard from Colorado. They didn't contact me, they contacted Dr. Jacobson and asked him some questions about my medications. Then they sent me a letter inviting me to Colorado, but first they wanted a current MRI with special pictures. My MRI's had always been

normal, but I was nervous anyway until I heard that it was still normal.

On 25 September 1996, the team of doctors met in Denver and decided that I would be an excellent candidate for the surgery, but one of the doctors was called away for an emergency and didn't read my MRI. It took him twelve days to find five minutes to look at my MRI. He is the neurosurgeon, and they tend to have tremendous egos. Many of them have God complexes, which come in handy when they are performing brain surgery.

I called the airlines and found out the cost of two roundtrip tickets to Colorado.

Sharon, the coordinator for the neuro-transplant program for Parkinson's disease at the University of Colorado Health Sciences Center, called on 8 October and told me that I would be scheduled for three days of testing the week of 4 November.

The only voice I had heard on the phone from Colorado those several months was Sharon's. Her voice had a serene aura about it. It made me feel secure. I conjured up in my mind what she looked like, but some people don't match their voices. I hoped she was as thin and ethereal as her voice sounded to me.

The doctors were going to be interviewing and exam-

ining me in three weeks, and I was going to be inter-
viewing and evaluating them. I considered making up a
questionnaire for them to fill out.

My level of sensitivity heightened. I became acutely
aware of sights, sounds, and smells. It was as if I had been
rehearsing all of my life for this part. Now, I was terrified
that I might forget my lines.

Flying Again

O n *Saturday, 2 November 1996, Ed and I boarded*
American Airlines flight 1797 to O'Hare, where we
changed to flight 515 for Denver.

I had been up since six A.M. and was ready for our drive
to Raleigh/Durham Airport, I was extremely excited. I
was flying again.

It was a long day, but it passed quickly as I was reading
Anne Lamott's book, *Operating Instructions*. She is a very
funny lady, and her sense of humor reminds me a little of
my own, which is why my friend Sally gave the book to me.

An old friend that I hadn't seen for eighteen years,
Judy Saurino, lived in Estes Park. She met us at the Den-
ver Airport and drove us to our hotel. Standing in the
baggage area, I started to shake as my medicine wore off.
When Judy and I made eye contact, she walked quickly

toward me and hugged me. Her eyes filled with tears. "You're still beautiful—but you're all fucked-up."

We hugged each other, laughing, as I turned to introduce her to Ed. Judy filled me in on her life to date. I shared my thoughts with her as we drove. She explained she was not having dinner with us, but she would have a drink.

Entering the Giorgio Hotel with its stark mauve, marble floors, softened by oriental rugs under couches of pale greens, pinks and burgundies, its baroque tables alive with huge vases of fresh-cut flowers, I had the feeling I had stepped over the threshold into a European hotel. A briskly burning fire added to the ambience.

We checked in, deposited our luggage in our room, which was on the third floor overlooking the mountains, and went to the dining room for cocktails. We again tried to persuade Judy to have dinner with us, but she declined.

I ordered a "pink lady," and the affable Mexican waiter looked at me quizzically.

I said, "It's in the book."

He was amused by this and went away smiling. When he brought our drinks back, he said to me, "It was in the book."

We ordered dinner and Judy left. I promised to call and keep her abreast of events as they unfolded.

Dinner was as good as the atmosphere.

In our room later that night we began to plot our schedule for Monday. I fell asleep almost immediately, leaving Ed in command.

Sunday was spent resting, watching television, and reading. We went for a walk, ate lunch at a local deli, and arranged for a rental car on Monday.

We had dinner in the hotel again, since we had gotten used to our Mexican waiter. That night I ordered a rosé blush wine. The waiter seemed surprised. "It's pink," I said.

"I see," he said nodding and laughing.

Dinner was outstanding.

After dinner we returned to our room. Ed was watching television as I slid in bed beside him and made subtle overtures that I was interested in him.

He smiled at me, "Are you sure this is a good idea?"

"The best idea I've had all day."

In the sixteenth and seventeenth centuries, people thought they were closest to death when they reached orgasm, but for me reaching orgasm is when I am closest to being alive. I wanted to feel alive again before the testing began.

.......................................

Testing, Testing, Testing
One - Two - Three — Testing

O*ur first appointment* Monday morning was at eight-thirty with Sharon Culver, the coordinator, in the main hospital. As we drove up to the main entrance, we saw a sign "Valet parking." I said to myself, "This is my kind of hospital!"

I had been up since six, when I took my first dose of medicine, but my body had been on Eastern Standard Time and there were two hours difference plus Daylight Savings Time in Colorado, which meant my body was three hours out of sync with my head. I assumed that I would need more medicine in four hours, which would be about ten, but my body had different ideas.

Sharon met us in the Health Sciences room—she was calm, pleasant, efficient, and slim. The lab where the blood work was done was brimming over with people, so Sharon decided I would have my EKG before the lab

tests. As we walked she explained that the EKG area was in the new wing of the hospital.

In the examining room I was asked to remove my blouse and bra, which I did quickly. I was lying on the examining table being hooked up to the electrodes when my medicine cut out and my legs started to tremble. The technician stopped smiling and asked if I could lie still. I informed her, indeed, that I not only could not lie still, but it would get worse, as my left hand started to tremble.

"We may not get an accurate reading, but we'll try."

By the time she unhooked me from the electrodes, my hands were "frozen." I was near tears and trying not to get hysterical when I asked the technician to get me a glass of water and to bring my husband to the examining room. The time was nine-thirty.

Ed calmly helped me into my bra and blouse, and I took my medicine. We walked back to the other wing of the hospital, and the lab was still full, so Sharon took us to Dr. Freed's offices and his nurse escorted us to an examining room. If you have ever been in an examining room you know that they are small windowless rooms, usually painted pale green, smelling of antiseptic. We had to wait a few minutes, but I was grateful because it gave

me time to compose myself and relax until the medicine kicked in.

Dr. Curt Freed was the Director of the Neurotransplantation Program. He was a complete surprise. He was sensitive, unassuming, and brimming with kinetic energy. I relaxed immediately as he and I shared a conversation.

"There are no guarantees," he said, wiping his glasses. "About one-third of our patients get better, one-third stay the same, and one-third get worse, but we have learned a lot from these patients and our techniques get better as we progress. However, you fit the profile of those patients who have responded very positively to the surgery. We have changed our technique from going in through the top of the skull to entering through the forehead. We make two tiny slits in the forehead and drill through the skull. The surgeon makes two needle passes on each side of the skull. After he plants the fetal tissue, he sews up the forehead and it is barely visible when it heals."

He enumerated the risks and talked about the one patient who had died from a hemorrhage.

He asked me to take off my blouse and put on a hospital gown, then left for a few minutes. He took my blood pressure; it was 120 over 88—very high for me, but I was

nervous. He listened to my heart, checked my ears and eyes, held my neck, and asked me to swallow. He looked at my EKG, which was normal.

We started talking about the history of fetal transplants, and he was impressed with my knowledge on the subject. We talked about Dr. Olenow's patient who died of natural causes two years after transplant surgery. The autopsy findings were very positive. They found his transplanted fetal cells had been alive and well and functioning at the time of his death.

Dr. Freed looked at his watch and said, "I have enjoyed talking with you so much that time has slipped away from me. I will see you again before you leave." He shook hands with both Ed and me.

Sharon was waiting in the reception room, and we finally got a break at the blood lab. The technician made a big fuss about what good veins I had. She took four vials of blood from me.

Our next doctor was Maureen Leehey, several doors down from Dr. Freed, also a neurologist. She was a pleasant woman in her early thirties who was very pregnant. I asked her when her baby was due and she said, "Friday."

Dr. Leehey examined me and took my blood pressure. It was now 150 over 95—unbelievable for me. I told her

that my blood pressure was usually 110 over 80 and hoped that she would believe me. Dr. Leehey was professional and efficient.

After seeing Dr. Leehey, we had lunch at the deli in the hospital. It was on a par with any New York delicatessen. Ed and I had corned beef subs, chips, and a coke—they really knew how to treat their patients in this hospital.

At one-thirty we were supposed to meet Dr. Cyndy McRae in the Department of Pharmacology at the medical school across the street from the hospital. There was a mix up and she had us on her schedule for two-thirty. By the time we verified all of this, it was too late to see her, and she would have to call us at the hotel.

By this time my adrenal glands had stopped pumping and I was running on fumes, so we returned to our hotel. I took a long nap interrupted by Dr. McRae calling to reschedule our appointment for the next day. We agreed to meet in one of the conference rooms in the hotel at ten.

Dinner was at an interesting Chinese restaurant. Now that we had a car, our horizons widened.

Tuesday started out to be a good day, but faded fast. Dr. McRae was a psychologist and the liaison between the hospital and the college.

She asked me a lot of psychological questions about

my expectations for the surgery. I told her that I knew it was experimental. The bottom line was that I could die or be maimed by a stroke or blinded, but my alternatives eventually would be as bad. With surgery I had a chance of being well and aiding science. I would be willing to take that chance. "Being alive can be hazardous to your health," I said in my closing argument to her. She seemed satisfied.

We were running late for my next appointment. It was across town at DCPA, Recording and Research. My medicine started cutting out. At the speech clinic with Dr. Lorraine Olson Ramig, I was almost panicky. I managed to get through the speech exercises, but I never stopped trembling the entire hour I was there.

We had only thirty minutes before our next appointment, and I hadn't had lunch. Ed pulled into a Burger King and ordered me a double cheeseburger, fries, and a coke. I took my five o'clock dose of medicine at twelve forty-five and prayed that it would work, since my next appointment was a six-hour session of neuropsychological testing at the Colorado Psychiatric Hospital.

Mind Boggling

Everyone *seemed to feel that the neuropsych testing* was the most difficult part of the examining procedure, but I was determined to do well. My medicine had started to kick in when I was introduced to Sue, my examiner. She was an intelligent, sensitive woman in her mid thirties—I liked her.

We began with blocks. My spacial concepts had been poor since birth. I arranged the first three sets of blocks after Sue assembled them and then disassembled them. She then changed to a book of pictures of blocks. I looked directly at her and said, "I can't do these."

The time seemed to pass quickly in the quiet room as I was presented with one set of problems after another. Sue played a tape recording of a short narrative and asked me to remember as much of it as I could. She played it at least five times, asking me after every time to relay the de-

tails to her. She presented me with a verbal shopping list and asked me to recite what I could remember.

I was shown six geometric figures and asked to draw them once the pictures were removed. Sue said that I would be asked four hours later to remember as many details of the narrative, shopping list, and geometric figures as I could recall.

Another interesting test was when Sue placed four square cards in front of me—one red triangle, two yellow squares, three green trees, and four blue circles. She gave me a stack of cards and asked me to place them on the square cards in front of me one at a time. I placed a green triangle on the red one and Sue said "wrong." I then placed three yellow squares on the three green trees, and Sue said "right." Sometimes she wanted color on color, sometimes she wanted the number of objects to match, and sometimes she wanted the same shapes on each card. She changed her objective about every third or fourth card. I did very well at this.

I was given some math, some reasoning questions, a lengthy oral vocabulary test, and several dexterity tests. One dexterity test was a small wooden box with a numerical counter inside and a lever outside. I had to keep my hand, including my thumb, flat on the table and push

the lever with my forefinger as fast as possible, releasing the lever at the top of its cycle each time. Each time this was done correctly, the count inside increased by one. I scored the highest with my left hand.

When the testing finally came to an end, Sue said that she had enjoyed working with me and that I had done well on the testing. She gave me two questionnaires to fill out and get back to her. One was five hundred questions.

I Craɜh an∂ Burn

After the neuropsych testing, I was exhilarated and felt like a very clever girl, but it didn't last long. After six hours of testing, my body and mind were exhausted.

As we drove back to the hotel, I was making overtures to Ed that we should go out and celebrate, but he wisely suggested that we have dinner in our room. Room service brought Ed a turkey club and me a Cobb salad. I started to fill out the five hundred questions and made it through two hundred and fifty-six before I came unglued.

I took one of my Fiorinal III headache pills because sometimes they helped me to sleep, but it had the reverse effect and made me hyper. By this time it was twelve o'clock and Ed was asleep. I took another Sinemet (dopamine), and the shaking and muscle spasms just got worse. I tried lying down, standing up, and sitting

up for three and a half hours, and I just shook and trembled.

At three-thirty, I decided to take a hot bath to try to relax all of my muscles. I started the tub water. As it gushed in the tub I immersed my body into the hot water. I lay there feeling the water gently massaging my body for about ten minutes. When I tried to sit up I couldn't. I tried again and couldn't move. I considered calling out to Ed, but I knew he couldn't hear me. All I could hear was the sound of the water rushing in.

"You're going to drown in the bathtub in Denver, and nobody will ever know why."

I tried reaching for the recessed slippery soap dish without a handle with my right hand and for the shower curtain with my left. "If the shower curtain doesn't rip—I'll be out of here." After several attempts, I finally pulled my body to a sitting position and turned off the water, but the bathroom floor was as slick as ice so I had to really dry my feet. I looked at my nightgown. Mustering up the dexterity to put it on was the last straw.

Ed wakened from a dead sleep to find me standing naked in the middle of the room, sobbing.

He took charge of my nightgown and put it on me,

then gathered me up in his arms like a small child and carried me to bed. "You're going to be all right. Just go to sleep, go to sleep, sleep, sleep," he said as he cradled me in his arms.

I slept until about seven, and then ordered breakfast from room service because all of that shaking had made me hungry.

The Neurosurgeon

Breakfast on Wednesday morning perked me right up. I displayed none of the symptoms of the night before. It was almost as if my body had given up and would try to behave.

Our first appointment was at nine-thirty with Dr. Robert Breeze, the neurosurgeon. It was my most important appointment, and it was imperative that I liked him and felt comfortable with him.

Dr. Breeze's offices were across the hall from Dr. Freed's. His nurse took us to an examining room and took my blood pressure. This morning it was 110 over 80. We waited a few minutes before a tall man in his early to mid-thirties or boyish forties introduced himself as Dr. Breeze. As we shook hands, I noticed his long, slender fingers.

He made immediate eye contact with me, but it was clear that no one was allowed in his space. His features

234 / *F l y i n g L e s s o n s*

were angular, but not sharp. He was pleasant and an-
swered all of our questions, but I felt he was distracted and
would rather be somewhere else. Hospital "PR" was not
his forte. Dealing with patients outside of the operating
room was something he did because it was expected of
him. I sensed no arrogance about him—just a quiet self-
assurance.

He explained the procedure to us. A measuring device
called a stereotactic frame is clamped tightly to the head
with four prongs and then the patient is put into the MRI
and all of the coordinates of the brain necessary for the
surgery are plotted. This whole procedure, including the
surgery, takes between three to four hours. The patient is
awake, although heavily sedated, during the entire pro-
cedure. He talked about my having to take an antiseizure
medication for a few days after the surgery. He spoke with
an air of quiet confidence. When we had finished with
the interview, I was comfortable about placing my life in
this man's hands.

......................................

The Mask

She wears a mask
plays the clown
spins tales
juggles time.

Behind the mask
watchful eyes
betrayed by fate
stare at strangers.

Unmasked
clown face boxed
scrubbed clean
naked
she rests between acts.

Two More Appointments

O*ur appointment with Dr. Ramig at the speech clinic*
went well, I thought. It was eleven-thirty. I was much
more relaxed, but I couldn't get any feedback on my re-
sults. I could only guess that I did fair.

After the voice appointment, we stopped by a fast food
place and got a coke and fries. There was a woman sitting
next to me with a guinea pig in a cage. She could have
been from another planet because she certainly wasn't
tuned into earth.

"What is your guinea pig's name?"

"Chloe, but they tried to steal Ralph last night. That's
why I brought Chloe with me."

I could see that this conversation wasn't going any-
where that I wanted to go, so I just smiled and nodded
every time she spoke.

We ate our French fries and drank our cokes. I asked
her to say "Hi" to Ralph as we left.

Our appointment with Dr. Christopher O'Brien was a delightful surprise. He told us that he had seen over eight hundred Parkinson's patients ranging in age from twenty-two to eighty.

He asked me if I had ever contemplated suicide.

I said, "Hasn't everyone?"

"No, I don't think so."

"It has been my experience that there are those who admit that they have and the liars."

We both laughed as I added, "However, for your edification, I am not at this time contemplating suicide."

He examined me and, as were most doctors, was impressed with my balance. He said that there was a new injection procedure that could prevent muscles in my left leg from misfiring.

Ed and I both felt that he was the most dynamic doctor that we had met for a long time. He said that he would write to Dr. Jacobson with some suggestions about my medicines.

Later that night, Dr. Freed called the hotel and apologized for not getting to see us again, but that we had to sign the consent for surgery. We arranged for Sharon to come by and pick it up the next morning.

After the Dress Rehearsal

Flying home we were tired, but full of optimism and hope, now that the testing was behind us.

The past three days had been strenuous, but uplifting. I had met "the group," and there wasn't one doctor that I didn't like or even had any reservations about. I would be scheduled for surgery some time in the next several months, and the "dress rehearsal" was so good that I was relaxed about the time frame.

I glanced over at Ed as he dozed in his window seat. He was exhausted because I had drained all of his energy getting through the week. He never wavered, never faltered, and gave me all he had to give.

In most marriages, people become one—but which one? This is not the case in our marriage. We are still two very

significant human beings, but our souls are joined together in that quiet place in our minds where truth, faith, and hope flourish.

It is nurtured by trust and love. I am so very fortunate to have found a man who is not threatened by me and loves me beyond all boundaries humanly possible. I know now that even if the operation is not all I hope for, my life has been blessed through sharing it with Ed, and that we will cope, together, with whatever life has in store for us.

Hope

There is a private place
In the soul
Where wing feathers sprout.
Hope is the key
That lifts the latch
And lets them out.